CATALAN NOTEBOOKS

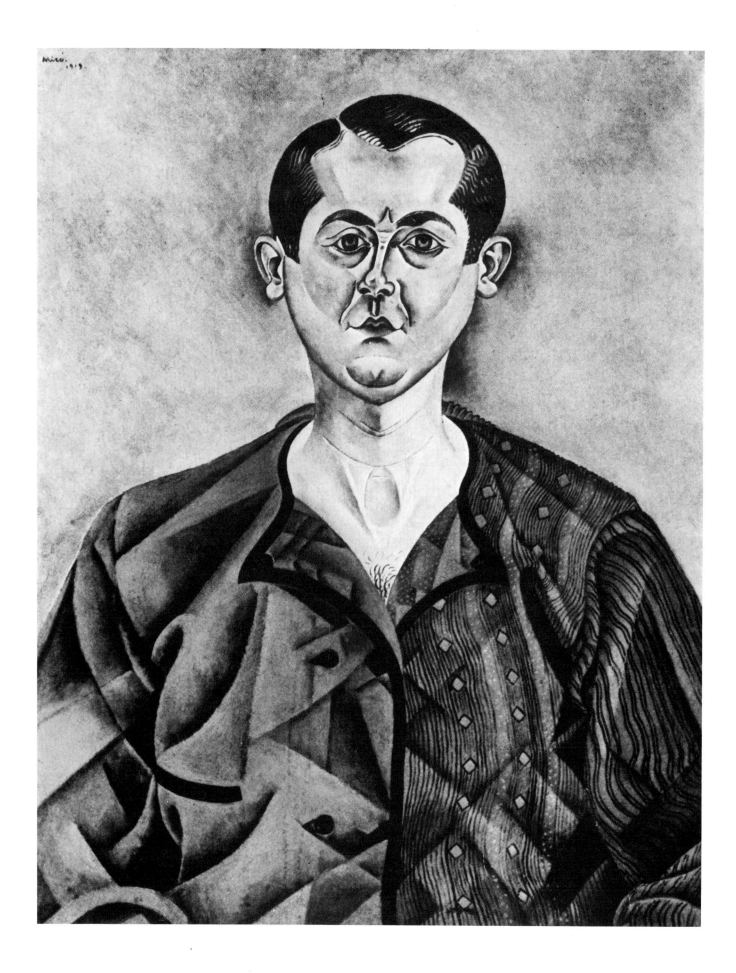

JOAN MIRÓ

Catalan Notebooks

UNPUBLISHED DRAWINGS AND WRITINGS
PRESENTED BY GAËTAN PICON

SKIRA

ACADEMY
EDITIONS

Frontispiece: Self-Portrait, 1919.

First published in Great Britain in 1977 by

Academy Editions
7 Holland Street
London W8

© 1977 by Editions d'Art Albert Skira S.A., Geneva

Translated from the French by Dinah Harrison

Printed in Switzerland

CONTENTS

Introduction by Gaëtan Picon 7

Studio Talk: Miró and Gaëtan Picon 9

Unpublished Sketchbook of 1930 27

Studio Talk: Miró and Gaëtan Picon 55

Unpublished Notebooks:

 I Bullfight, 1940 106

 II In Memory of a Poem, 1940-1941 108

 III Large Palma Notebook, 1940-1941 116

 IV Daphnis and Chloe, 1940 120

 V Palma, Majorca, 1940 121

 VI "A Woman," 1940-1941 125

 VII Orange Notebook, 1940-1941 133

De l'assassinat de la peinture à la céramique ('From the Murder of Painting to Ceramics'): Unpublished text written in French and illustrated by Miró . 141

List of Illustrations 155

Introduction

If ever a book shed light on the byways of creation, it is this one, for it traces the steps leading up to a finished picture. All too often the latter alone appears before us, cut off from all the work that lies behind it, and we have the illusion that it sprang into existence at one stroke.

When Teri Wehn-Damisch, Jacques Dupin and I went to see Miró in Majorca in the fall of 1975, he let us look through the notebooks that are now preserved in the Miró Foundation in Barcelona. Most of the drawings in them, dating from 1924 to 1940, reproduced in the first half of this book, have never been published before, and they are clarified by commentaries by the artist and myself. The earlier drawings provide valuable insights into the transition from figural to symbolic notation, to the sign, in Miró's work; as a whole they help us chart the transition from sketch to painting. Some of the drawings were never worked up into pictures, and the glimpse of what might have been is also interesting. The land of creativity is crisscrossed with the byways that Heidegger speaks of, byways leading nowhere, but now and then opening unsuspected vistas. We can see here that the final work, the irrevocable act of creation, was initially an intention, a latent power, and in some cases we can also see the unfolding process of selectivity that shapes the end-product.

The 1930 sketchbook, reproduced here in its entirety (see pages 27-54) is perhaps the only instance in Miró's work of drawings done for their own sake, not as the preliminary to a painting.

Miró also showed us some notebooks containing a sort of diary kept in 1940 and 1941, first in Varengeville (Normandy), then in Palma (Majorca), and written in Catalan. Only a few sketches punctuate the closely packed sentences; technical tips occur side by side with general reflections, such as statements like this: "Let my work be like a poem set to music by a painter." The kinship between these Catalan Notebooks (of which extensive extracts are given here) and the drawings is obvious; both shed light on the workings of the creative mind, one in words, the other in pictures. They show Miró testing out and building up the work of those years, primarily the gouaches and tempera paintings that were later entitled *Constellations*. Above all, they give us an insight into his thoughts and his projects, some carried out, others abandoned. Miró kept this 1940-1941 diary during a lull in his working life, at a time when he was not painting any major canvases. But he was storing up impressions through his experiences, his theories on technique, his studies of other artists' works (Braque, Picasso, Arp, Dali), and mainly just by living, going to bullfights, listening to organ music, and steeping himself in the grim atmosphere of that period so as to exorcise its evil. Like the drawings he never finished, these descriptions of the occasional concept that never developed into a painting show how work evolves through the elimination and sacrifice of possible elements. And, since we are talking about words, not pictures, his diary also shows that, in spite of current theories, a painting is not born only of a painting: it arises from experience. Some aspects of existence and experience might be discarded or modified in the final work, but their presence and confused power, however repressed and silent, are basic to the work.

Studio Talk

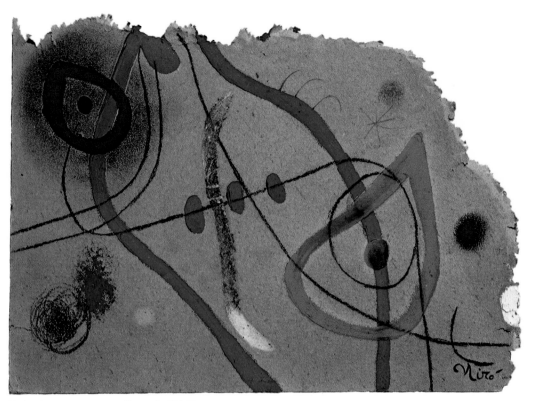

Painting on torn cardboard, 1975.

"This!" said Miró.

He stood in the big studio he had dreamed about and now owned. He was going to spend a few days showing us sketchbooks, notebooks, and exercise books with torn, faded covers containing hundreds of drawings, most of them never reproduced, some completely unknown, and several that he had even forgotten himself. He also showed us his collection of stones and pebbles, bargains he had picked up at various flea markets, photos tacked to the wall, and the tiny, often surprising tools with which he creates his art.

"Look at this!" Miró pointed out the different aspects of his work as if "this" were the only explanation needed, as if it were possible just to take in all those shapes that someone else had created. "This": the impact of an overwhelming, as yet unnamed reality incorporated into a universal language, the astonishing, improbable shapes that nobody knew he harbored.

Miró works in his studio every day, giving birth to "this" art; he is the intermediary between nothingness and the created object. He stopped work in order to make an inventory of his

creations with us. He has written the year, the day, sometimes even the time of completion on each drawing, yet all his lines are fluid and float on the same turbulent surface. Time? "Time doesn't matter," he kept saying. "I belong to the daytime." He does not date his work in order to chart his progress but to keep some record of his constant activity. Inspiration is never far away; the drawings he dates each day can inspire new ones when he comes across them again a long time later. Even years after the event, an idea can dovetail into one preceding it by ten or twenty years—the date shows that imagination transcends time and that creativity is outside time.

"Woman, bird." Drawing, 13/4/57-24/II/75.

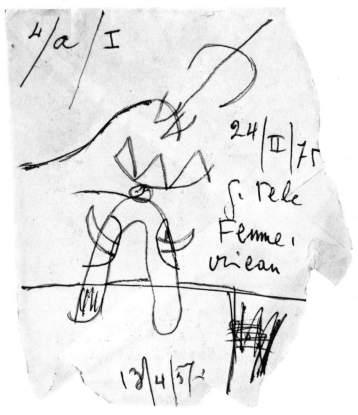

"You see, I'm putting things in order," said Miró. "And while I'm getting them together, I keep coming across things I can use as starting points. Reworking things as time goes on fires my imagination. I did this drawing twenty years ago: it's dated 13/4/57, and I don't have a clue where it sprang from. And I was going through my drawings on the 24th of February 1975, and I thought, aha! this could trigger off something interesting. So, as you can see, I added on to it: I did the black lines in 1975, the blue ones in 1957. It's not a new version at all; its impact sparked off another shape. I don't evolve, I skip from one thing to another. That's why I never know how anything will turn out. It may not work at all; it may end up in the wastepaper basket. I couldn't say why I don't like a given drawing, or why I feel I can't make anything of it, I just don't like it, that's all. I also destroy canvases sometimes if they don't work out. These drawings are only possible starting points, and nothing more. I file them away with their dates, usually with a title—'Woman in the night,' 'Man pissing by starlight.' Some subjects keep cropping up again and again, so my current work is really a meeting of past and future. I store them up like seeds. Some of them grow, others don't. I have to let ideas develop in my mind, as if they were outside me; waiting is work too, and so is sleep. I merely fuel the tank. It's like a child gestating in the womb. My work develops in the same way. I remember Matisse used to say that when he was painting a portrait he never looked at his model but learned him and drew him from memory. If I were to paint your portrait, I wouldn't look at your face, I'd learn it by heart. That's what Matisse said. So every idea has to develop in my unconscious, and sometimes it takes years. When an idea is

10

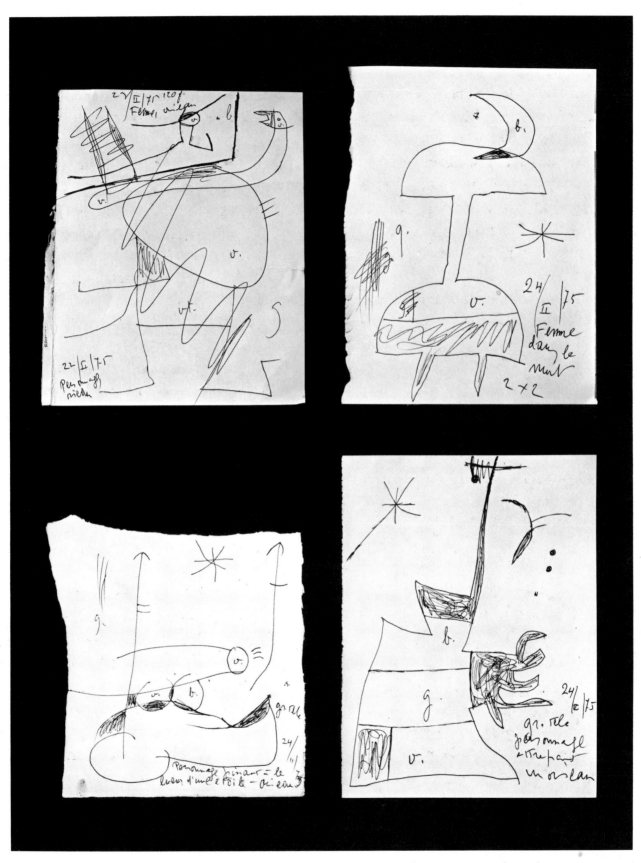

Upper left: "Woman, bird." Drawing, 22/II/75.

Upper right: "Woman in the night." Drawing, 24/II/75.

Lower left: "Man pissing by starlight and bird." Drawing, 24/II/75.

Lower right: "Person catching a bird." Drawing, 24/II/75.

11

ripe, I begin working on it—quick, brushes, canvas!"

Miró may do a lot of his work unconsciously, but when he examines the note on a drawing he is working completely consciously.

"The starting point is absolutely irrational, sudden and unconscious; I start off blindly. But the next day—or twenty years later, it's all the same thing—I study my work coolly, after I've slept on it, and I'm certainly critical then."

The recent drawings he showed us were not preliminary sketches but ideas jotted down at random, some on a subway ticket or a page of his Hermes diary. They were too diagrammatic and haphazard to give an idea of a finished painting, but they did have a definite, if revocable link with the uncreated canvas that may never come into being.

"I put down the format I visualize—2 × 2, 120 fig. I see this drawing as a large canvas. And I often write down a color scheme: g.r.b. But color notes are based on the size of a drawing, and a full-scale canvas would undoubtedly be slightly different from the drawing, and if I changed the drawing I'd probably have to change the colors. I don't decide anything beforehand. This is just a starting point. When it comes to the crunch and I'm actually working on the canvas, only my hand has any say in what I could and should do."

Besides the drawings with their rough concepts of shape and form, there are plenty of random suggestions for subjects and media in Miró's studio.

"This old, ink-stained newspaper... I had to replace it with clean paper, but first I dipped my fingers into my paints and smeared color over it. I often paint with my fingers. I need to steep myself in the physical reality of ink and paint, and I need to be covered in dirt from head to toe. This fresh paper will probably end up like that old newspaper. When I do lithographs and engravings I put sheets of paper next to the plate and wipe my brushes on them. I put paper on the floor too. I've even pissed on it. That could be another starting point! The green blotting paper and the piece of crumpled cardboard are suggestions for media. And these are my tools; the tools I use are very important, but I don't use many conventional ones. The feel of copper and zinc inspires me. I've got this toothpick, this little brush I bought in Paris at a drugstore in the Rue du Dragon, and this goosequill. I hang on to everything. A color, a texture, a tool—it could always lead to something."

Painting on paper, 1975.

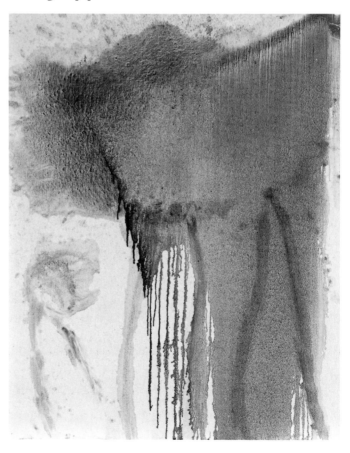

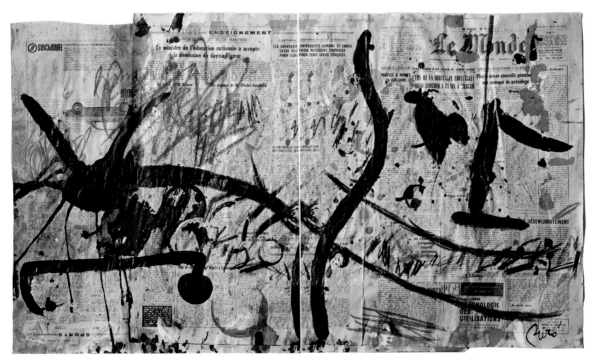

"Le Monde," 18 March 1970.

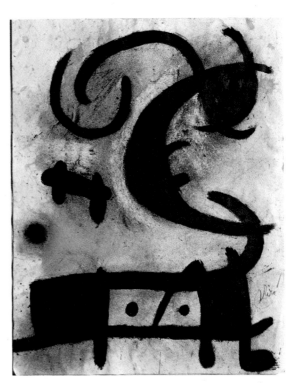

Painting on paper, 1975.

Painting on paper, 1975.

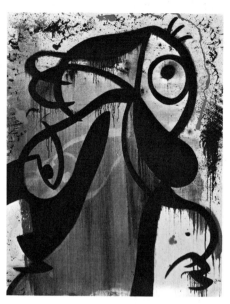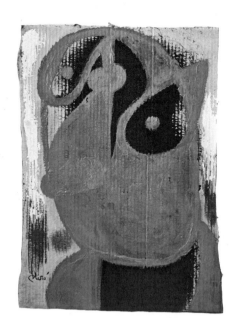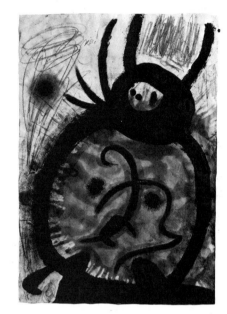

Four paintings on paper, 1975.

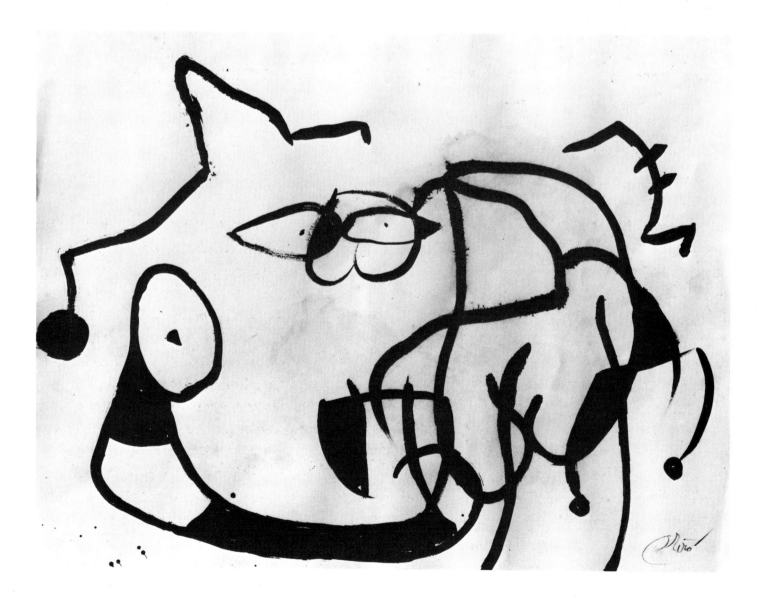

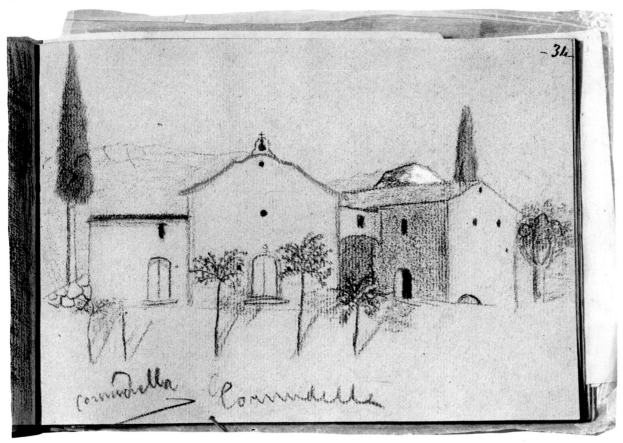

"Cornudella." Drawing, 1905-1906 notebook.

"Oh, I'm glad to see that again," Miró said.

It was one of his earliest sketchbooks, dating from 1905-1906. Some drawings of his from as early as 1901 (when he was eight years old) still exist: fish, flower pots and a weird scene at the chiropodist's, all really a child's drawings. In these sketchbooks the artist was beginning to emerge. These are landscapes done from nature, as found in his earliest canvases, drawings in charcoal, red chalk and pencil with an occasional touch of gouache or pastel done on Ingres paper. They represent the countryside around Tarragona and Montroig, the Catalan village near Prades where he spent much of his boyhood; they represent the Catalan villages of Ciurana and Cornudella, the sea and Palma in Majorca. Some elements, such as the sea, are

drawn with a clarity already anticipating the detail of *The Farm*. But the most striking thing is Miró's feeling for the whole, the roofs unfolding continuously, like a chain of mountains, and the unity of the space enveloping them.

"Isn't that nice? The wide blue surface, and the touch of red, and those black lines. It's modern, isn't it? One single touch of color, like the red bracket of the roof, or the yellow moon there—I did that drawing outdoors one night when there was a full moon. And only one little cloud in the sky in this one. I was very aware of wide, empty spaces punctuated by one tiny object. There was a painter called Modesto Urgell at my first art school, La Lonja in Barcelona, who painted desert landscapes with cypress

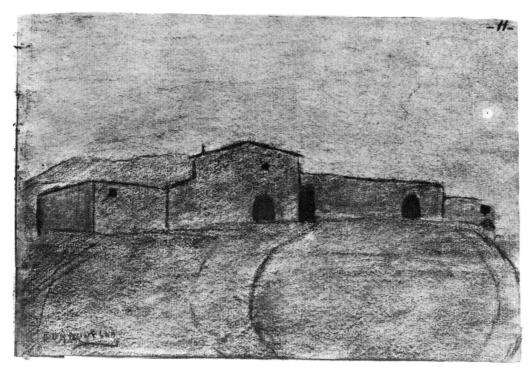

"Cornudella." Drawing, 1905-1906 notebook.

"Palma de M." Drawing, 1905-1906 notebook.

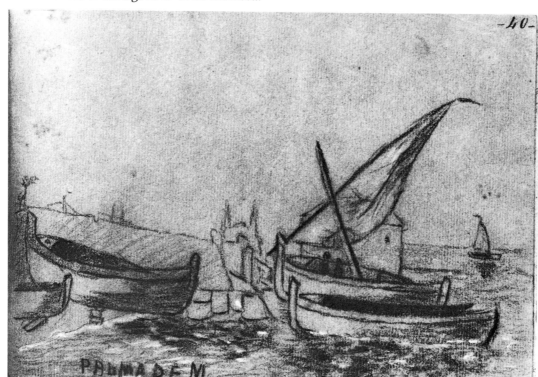

16

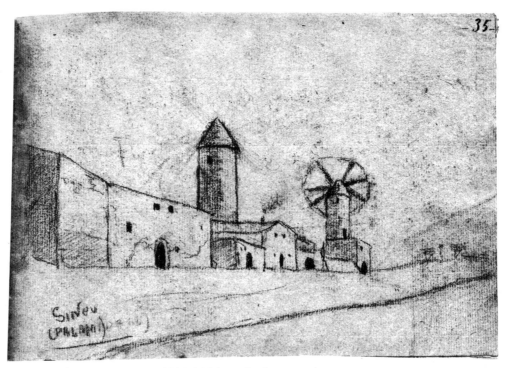

"Sineu (Palma)." Drawing, 1905-1906 notebook.

trees and cemeteries, and he always included the line of the horizon, a broad tract of space above the horizontal composition of the houses. I never forgot that; I even did a drawing after one of his paintings. Look how I dealt with space here—the black note of the half-open door, and the loopholes punctuating the gray surface of the wall, and the thicker mass of cypress trees. Oh, here's Palma, with the cathedral in the background, and the windmills. This is the port at La Lonja, with boats. I did very few drawings of the sea. I was more interested in the hinterland. I always went back to these houses, the plain and the mountains. I was particularly inspired by Cornudella, near Montroig, where my grandfather came from; the soil is so incredibly red.

Every year, when I go back to Montroig, I hire a car and drive round that part. I found my footing in Montroig and, as I always say, strength enters through the feet. I'm really glad to see all these again!"

The isolated, carefully spaced accents of yellow and red anticipate Miró's skill with color. Though he has often spoken of his initial clumsiness in that direction, the 1906 draftsman seems to have been a talented enough colorist. The sketchbooks we examined next confirmed it. These dated from 1915 to 1919, and contained nude studies done at the art academy of Francisco Gali in Barcelona and the Sant Lluch drawing school.

"I couldn't draw at all. I couldn't tell a curve from a straight line. Gali made me do a still life of rather colorless objects, a glass of water, a vase and a potato. Well, I produced a sunset! Gali, whose private school I attended from 1912 on, was very receptive to modern art, whereas the La Lonja school was very academic, and he came up with a good dodge for me. He told me to close my eyes, feel an object or even a friend's head, then draw it from purely tactile memory. Yes, that's why I have such a feeling for volume and find sculpture so interesting, though I didn't try sculpture till later on. Anyway, these nudes were drawn as much from my sense of touch as from life!"

Miró's volumes here are certainly harshly stressed and exaggerated, sometimes made up of several dovetailing pieces; they foreshadow the 1918 *Standing Nude* and the 1919 *Nude in Front of a Mirror*. Hatching replaces surface relief in order to add volume. But Miró was already getting away from his concern with reproducing an exact impression of tactile or retinal reality, and beginning to move toward a more personal view of reality through the use of signs. This is noticeable in the closed circle of the breast, and, in this pen drawing, the attenuated lines without shading, the Matisse-like oval of the empty face, and the arm superimposed on the body, a fluid shape floating on top of another shape yet revealing its linear detail, a device that was to crop up again.

"These are rather elaborate drawings, because this was all serious work. We used to

Nude figure on all fours.
Drawing, 1915-1919 notebook.

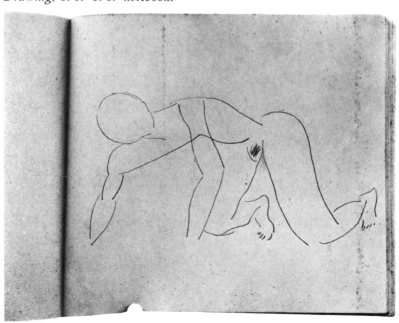

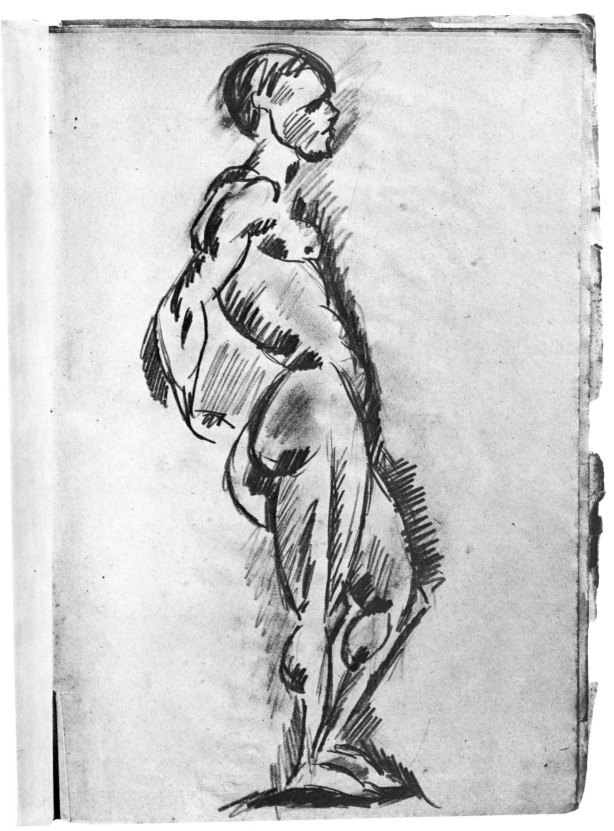

Nude study. Drawing, 1915-1919 notebook.

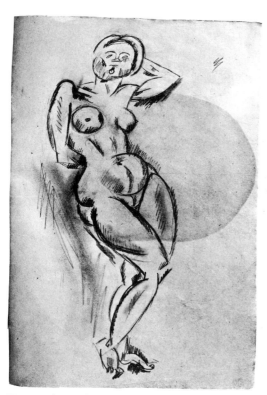

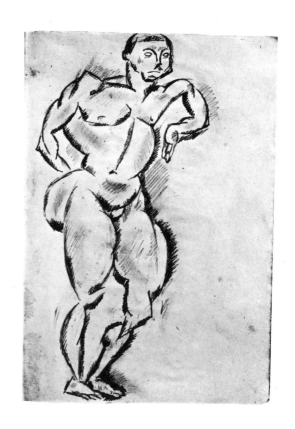

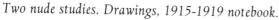
Two nude studies. Drawings, 1915-1919 notebook.

choose a pose for each week. This was at the Sant Lluch school, where I went until 1918. Ten years before, it had been a famous cabaret, *Els Quatre Gats* (The Four Cats). During our life sessions, we used to notice an old man sitting and sketching with us. It was Gaudí. We knew he was a great man. I've said that I would class Antoni Gaudí among the very greatest architects. Picasso also went to Sant Lluch. But I often sketched elsewhere, particularly at the Molino, a well-known Café Concert in Barcelona. It's still there. Like Toulouse-Lautrec, I enjoyed studying the women dancing and singing!"

Miró had just mentioned Toulouse-Lautrec, and one of his drawings was reminiscent of a Matisse. What had he known about modern art at that time?

"Gali used to talk about Manet, Van Gogh, Gauguin, Cézanne, and even the Fauves and Cubists. We used to spend our breaks discussing art nineteen to the dozen. But we only saw reproductions. We didn't get to see the originals until the big exhibition of French art in Barcelona in 1916; Vollard had made the selection. There were Manets, Monets, and even some of the earliest Matisses. It was a real eye-opener! Remember, at that point I hadn't even been to the Prado in Madrid. The greatest revelation was a Monet painting—simply a sunset. Afterwards, in Paris, I was rather influenced by the members of the Section d'Or and also the Esprit Nouveau group, Ozenfant and Jeanneret, who all disliked the Impressionists and kept saying that Monet's paintings were so many rags on

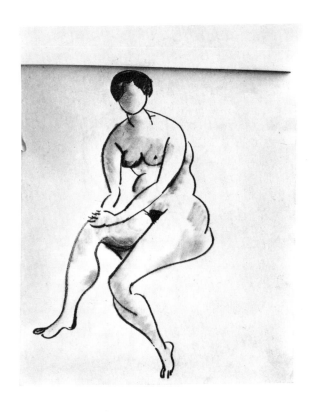

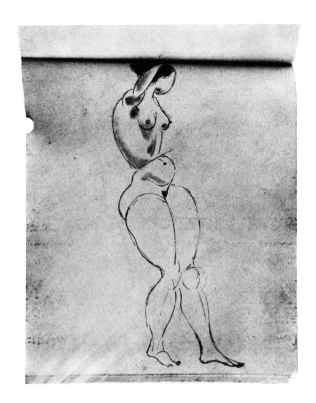

Three nude studies. Drawings, 1915-1919 notebook.

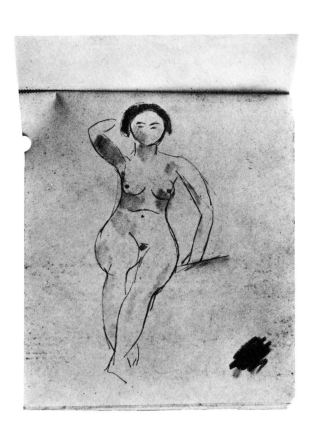

which he had wiped his brush. But I never felt like that. I never forgot my initial delight, and afterwards, when I was free from the Cubist influence, I rediscovered it in all its impact. Yes, when I was interviewed during my visit to the Louvre I said how important I thought Courbet was; you can even feel the impact of the *Burial at Ornans* when your back's to it! It really gets hold of you. But if I'd been taken to the Jeu de Paume I would have said how decisive my delight at Monet had been..."

So Miró learned to draw, but he learned so that he could paint. Did he ever draw for the sake of drawing, and not with a view to a painting? The sketchbook of 1930 shows that he did.

"I did these drawings at Palma during the first year of my marriage. I did large pencil drawings on Ingres paper based on this sketchbook; they're scattered now, but I once saw them exhibited at Colette Allendy's when I went to see a friend in Passy. The big drawings are exact reproductions of these. They weren't meant for paintings, but of course you can find some of the shapes that crop up again in the paintings. The toe, for instance, and the nail becoming a crescent moon. And the arms are like ears. This figure doesn't have feet or fingers, and he has only one toe. And his nail is like a moon. The object outside the woman? It's a wall, or a curtain, like in *Queen Louise of Prussia*. These are male sex organs—this one's a woman, but the shape of her feet brings us back to masculinity. I put an eye on a foot. And this figure is also a tree, one of the huge Montroig carob trees that never shed their leaves. You can see the trunk, the roots growing and the toenail or crescent moon."

Miró did other drawings for their own sake, drawings that are not in any way starting points for a different form. There are no preliminary sketches for those drawings, but they certainly did not spring out of thin air. On the actual

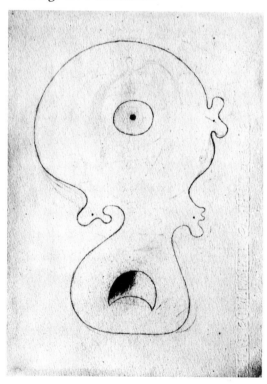

The toe and the toenail.
Drawing, 1930 sketchbook.

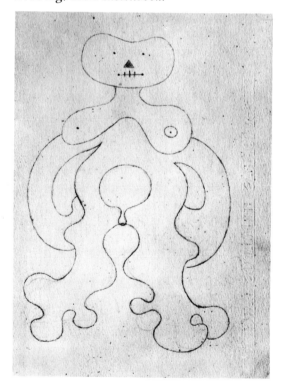

Woman with her hands akimbo.
Drawing, 1930 sketchbook.

paper, we could see the artist's development of his theme, his second thoughts, the erasures and the faint traces of lines left out in the final version. The impression is one of authoritative perception, that is, the need for evidence that is all the stronger for its unexpectedness, all the more forceful for its correspondence to a hitherto uncreated and highly improbable form. All the stronger too for not being conditioned by pictorial requirements; nothing can be changed, for any change would threaten something that is not so much beauty as life. The pictorial structure corresponds to the possibilities of existence. We do not know to what species, sex or background these ambiguous, amphibious figures belong: flying fish, tree-trunks whose summits brush the stars, beings stranded on some shore or floating in the water. But they are undoubtedly perfectly viable.

André Breton said that no one came closer than Miró to bringing together completely incongruous elements, *combining the uncombinable*. One figure has both a phallus and a vagina. Another one is a figurehead whose breast juts forward like the stern of a boat, but it is also a space craft with hair like the tail of a comet. The disc it holds by its side reveals its astral associations, as does the crescent moon on the nail of this foetus in which a humanoid eye is opening but whose protoplasmic appendages are neither ears, nose nor fingers. Miró's drawings contain continual activity between top and bottom. The pitcher fallen at a woman's feet then integrated into her shape is symbolically linked to the dreaming moon by the vertical of a ladder combining ascent and descent, a definition of human beings, for we belong both to the earth and the sky. Incidentally, Miró loved pitchers: "common objects that I adore; I'm sickened by rich women's silver pots and pans."

But Miró strips incongruous objects down to their basic elements, and shows them in their most succinct combinations. He has succeeded in reducing the most divergent elements to the simplest of signs by investing one sign with several functions. An object may be an eye, a breast and genitals, another a toe, a crescent moon and, elsewhere, a bull's horns. In spite of Breton's claim, Miró's idiosyncratic meshing of heterogeneous elements actually contrasts with Surrealism in which anomalous objects are kept apart. However, Miró's drawings are neither

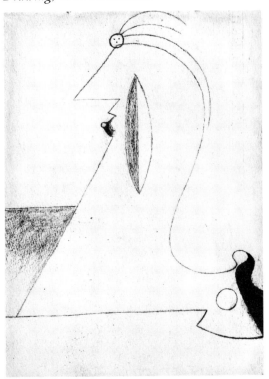

The curtain.
Drawing, 1930 sketchbook.

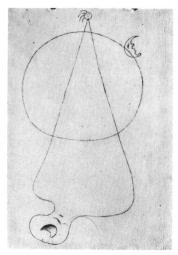

The nail and the moon.
Drawing, 1930 sketchbook.

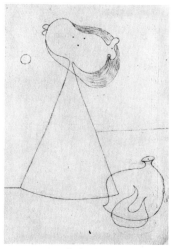

Woman and pitcher.
Drawing, 1930 sketchbook.

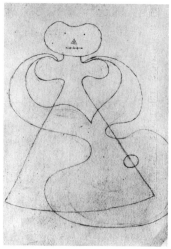

Woman and pitcher.
Drawing, 1930 sketchbook.

collages nor grafts; they represent the birth, through crossbreeding, of a new being whose components, however incongruous, are paradoxically reduced to one single shape or sometimes one continuous line. Life too produces some beautiful monsters, always working along the simplest of lines.

In these drawings Miró has taken the risk of creating the outline of a perfectly viable being in a single movement, without once letting his hand leave the paper, much as you draw a circle. The elements which, combined, constitute life, such as breasts, genitals, eyes, mouth, hands and feet, are appended to the surface of the linear boundaries. But there are a few internal elements too; however simplified, none of these figures is reduced to a mere outline. The ones most like human beings contain some internal detail; the figure here has three minute dots for mouth and eyes, and another eye on a sort of caudal appendage. In other drawings we find the oval curve of breasts, female sex organs, eyes, the half-moon of a finger-nail, or a nose. But none of these details suggests any internal organic complexity, for within the empty frame eyes and sexual organs are like a moon in a starless sky; their isolation reinforces rather than nullifies the impression of the vacuum surrounding them. Apart from a few complex creatures—hybrids, Centaurs, Minotaurs and prehistoric Pegasuses—the overall effect is of something homogeneous and simple, of a spark of life engendered from nothingness by a process of reduction.

However, a few of Miró's drawings comprise two separate shapes. Here, a very elongated oval bisects the stilt-like support of a hairy head, and elsewhere a circle bisects the triangle surmounted by a round face and ending

in a nail-crescent. One drawing is made up of two almost separate shapes, for the pitcher cuts into the triangle-woman so low down on the right that there is very nearly a gap between them. But these shapes are superimposed, not juxtaposed. In two of the drawings, the pitcher is apparently integrated into the outline of the basic shape, becoming part of a foot or a dress, as if Miró were trying to experiment with a single line carried as far as possible without losing its continuity. Some drawings are both unilinear and complex, containing lines that roll back on themselves following a duplicate track.

And the oval and circle bisecting the triangles in the above-mentioned drawings seem to be welded to the basic shape, and part of its construction. One can imagine these drawings as wire sculptures. Others are reminiscent of wood and bronze blocks, because of the way the shapes are built up in space. Miró's sculpture is very similar; he does not build up complicated and distinct volumes but usually produces a thrusting, simplified volume in one single piece, like a vase taking shape on a potter's wheel, unified surfaces with a very occasional internal detail. This *Woman* (bronze, 1950), looking like

Caudal appendage. Drawing, 1930 sketchbook.

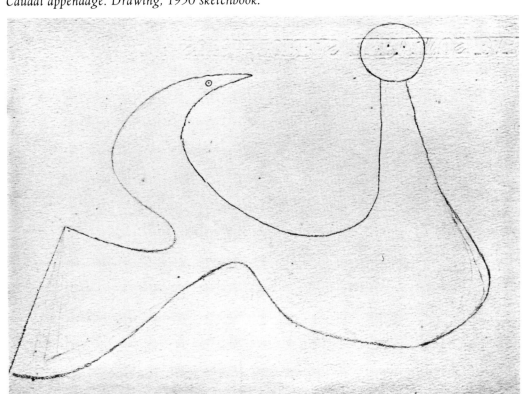

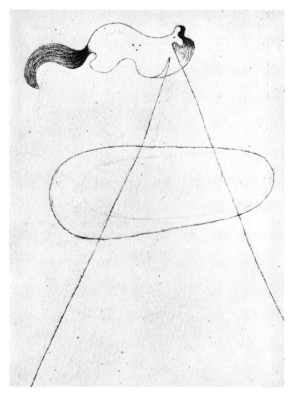

Oval bisecting stilts. Drawing, 1930 sketchbook.

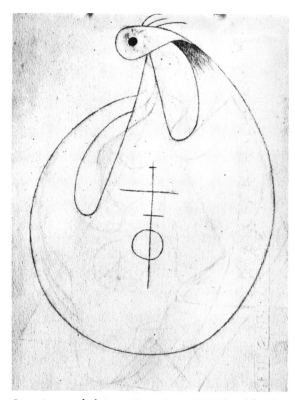

Superimposed shapes. Drawing, 1930 sketchbook.

Woman. Bronze, 1950.

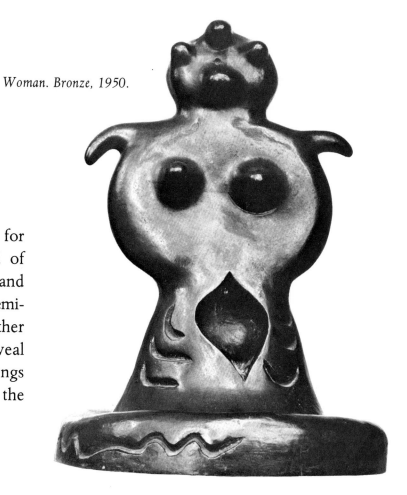

an erect seal with two very short stumps for arms, has a smooth body almost devoid of detail, except for the prominent breasts and gaping sex. The drawings are sometimes reminiscent of Miró's many primitive Earth Mother sculptures. But Miró as sculptor did not reveal himself till later, and the series of 1930 drawings are, of course, related to the paintings of the same era.

26

Sketchbook of 1930

This unpublished sketchbook of 1930 is reproduced
here in full, in its original size

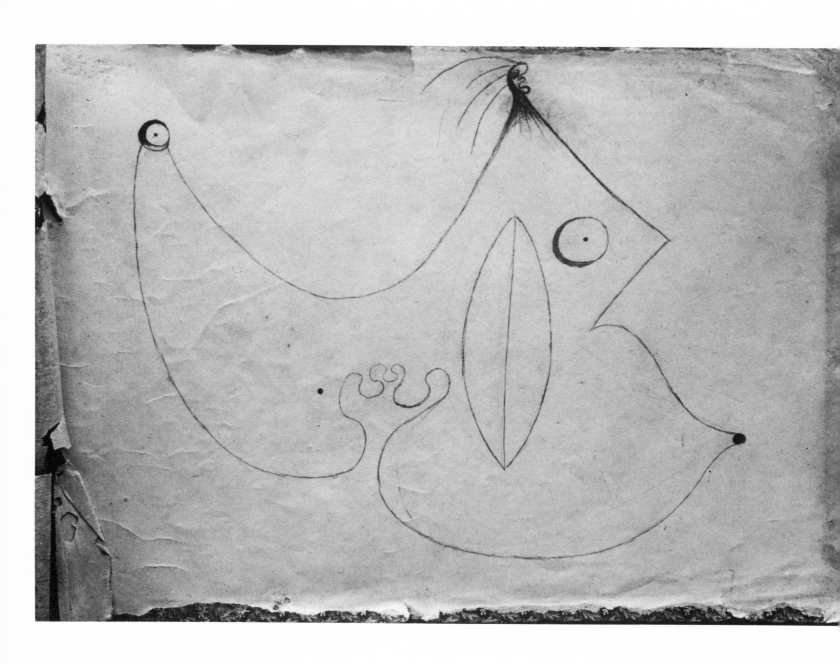

28

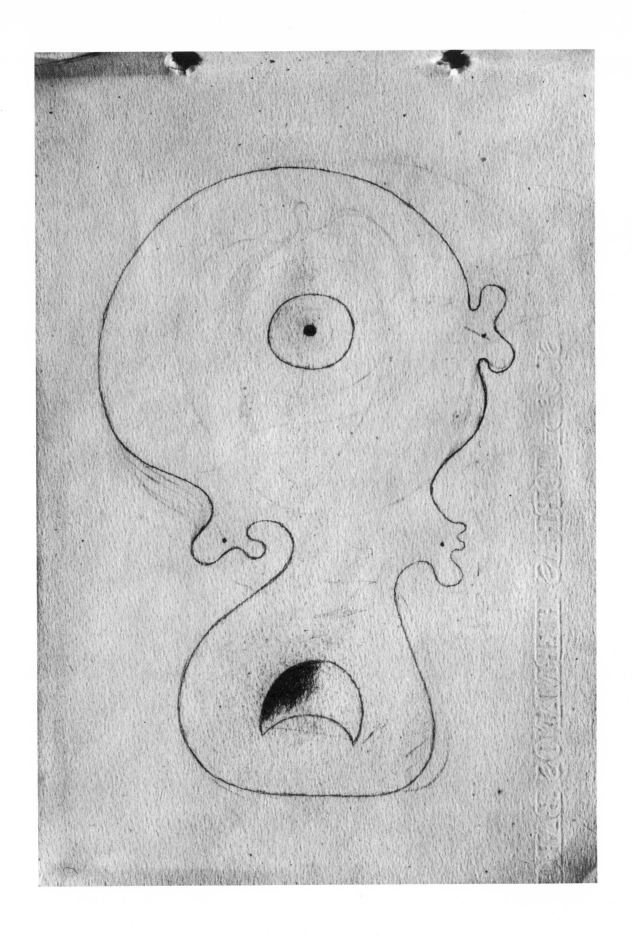

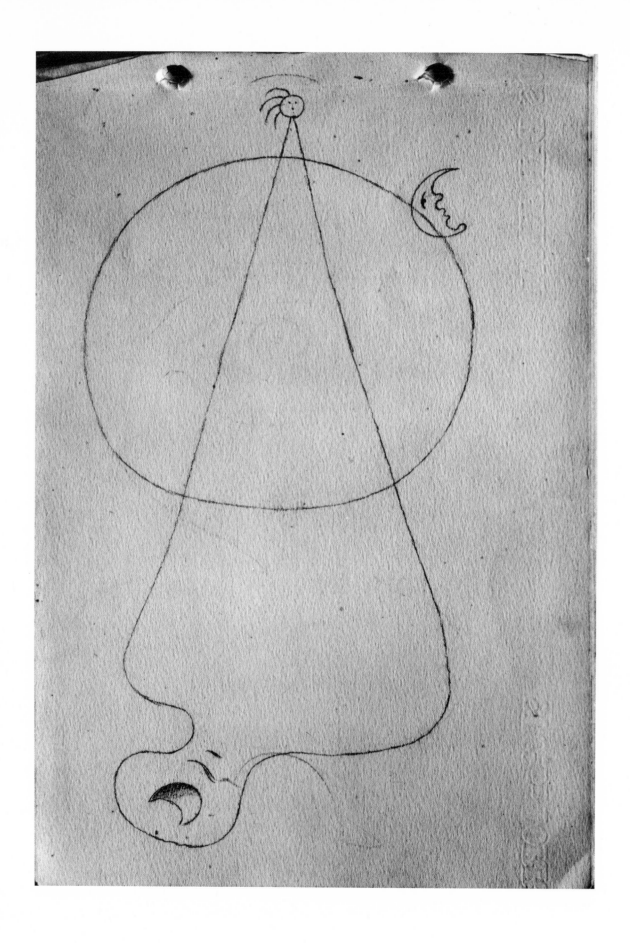

30

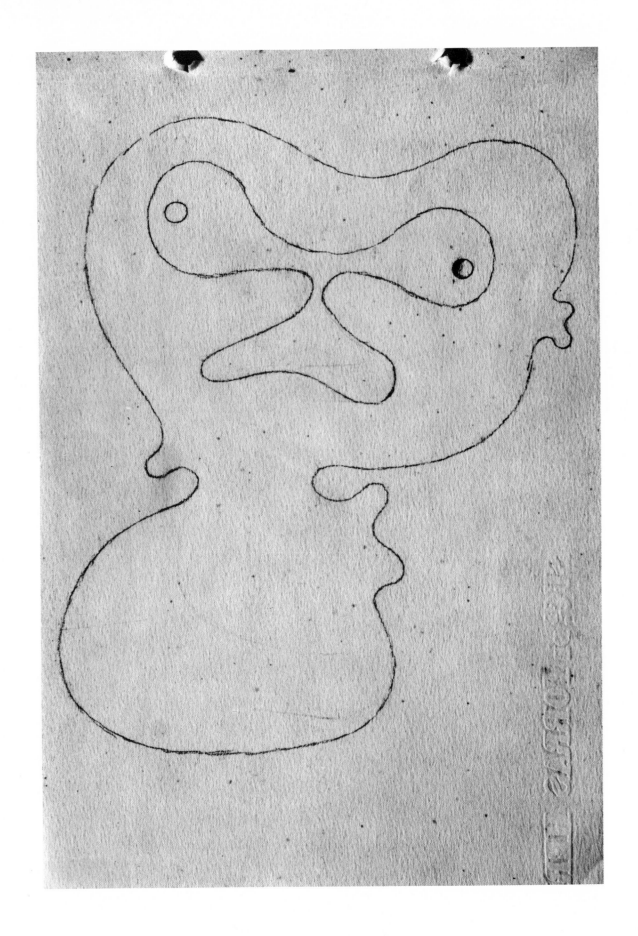

31

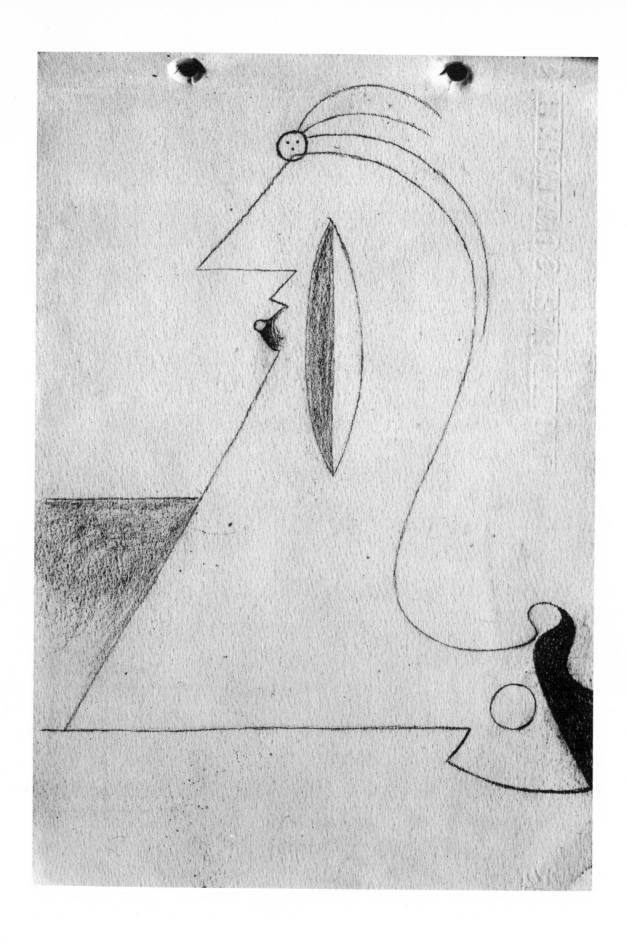

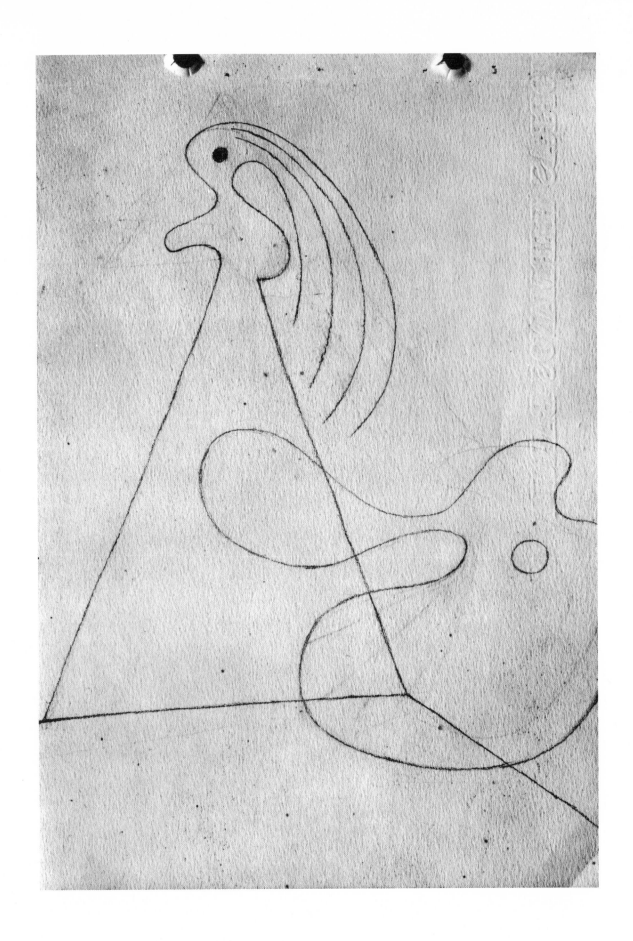

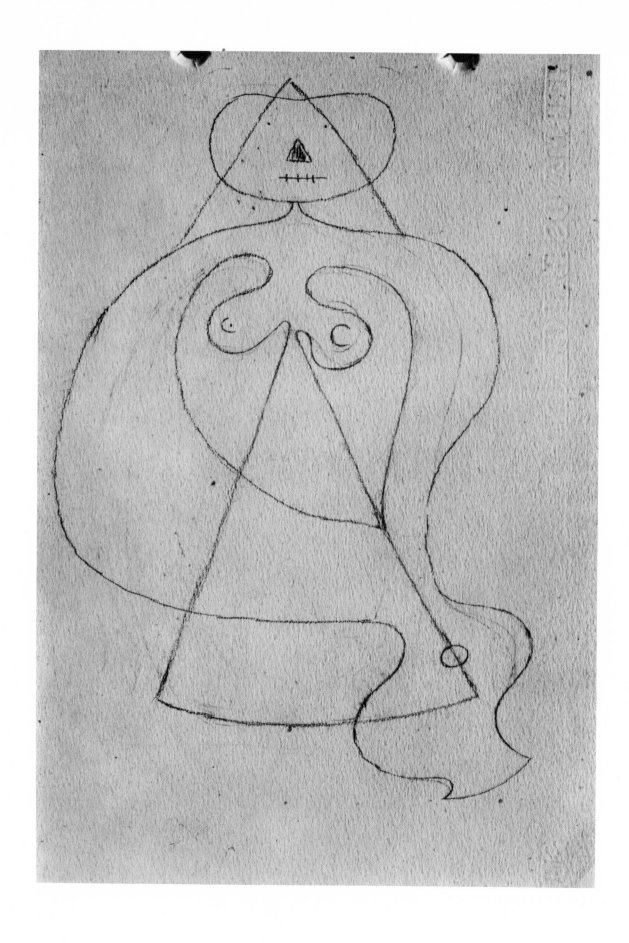

34

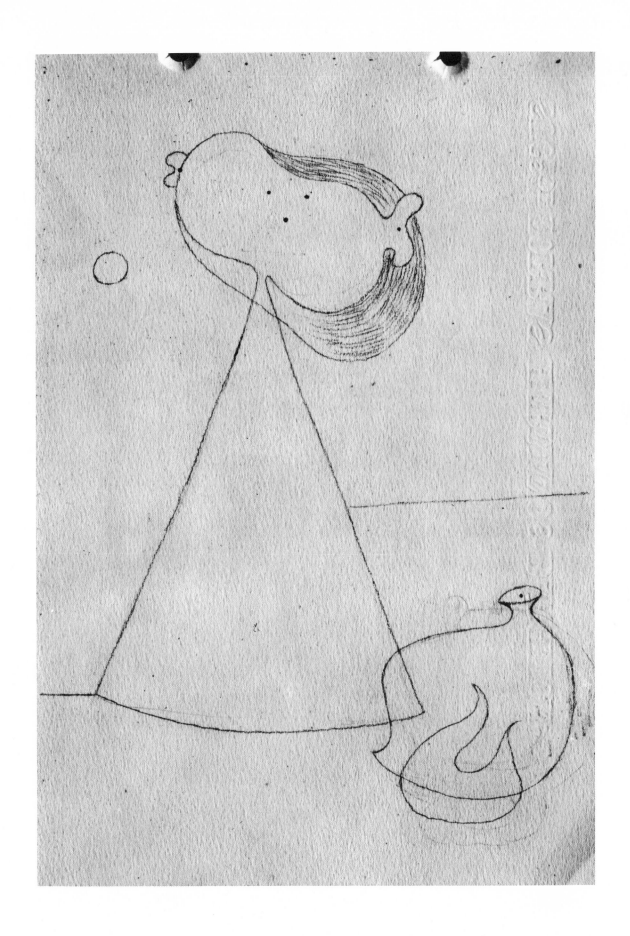

36

38

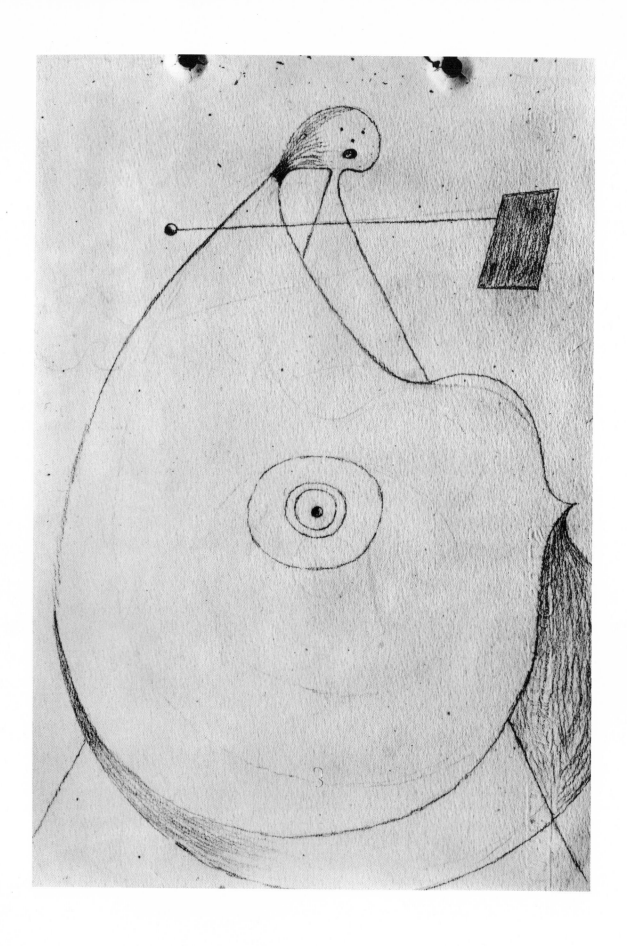

40

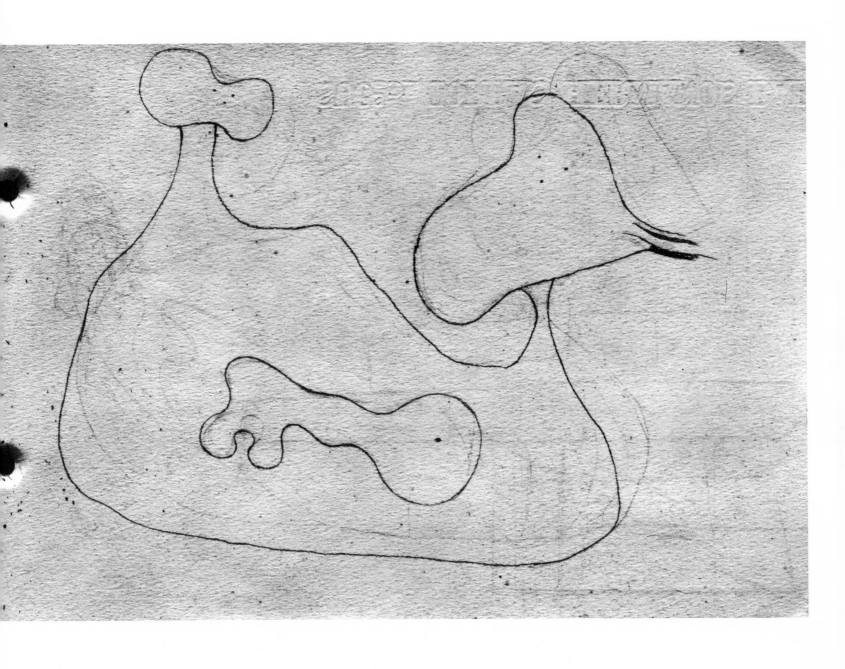

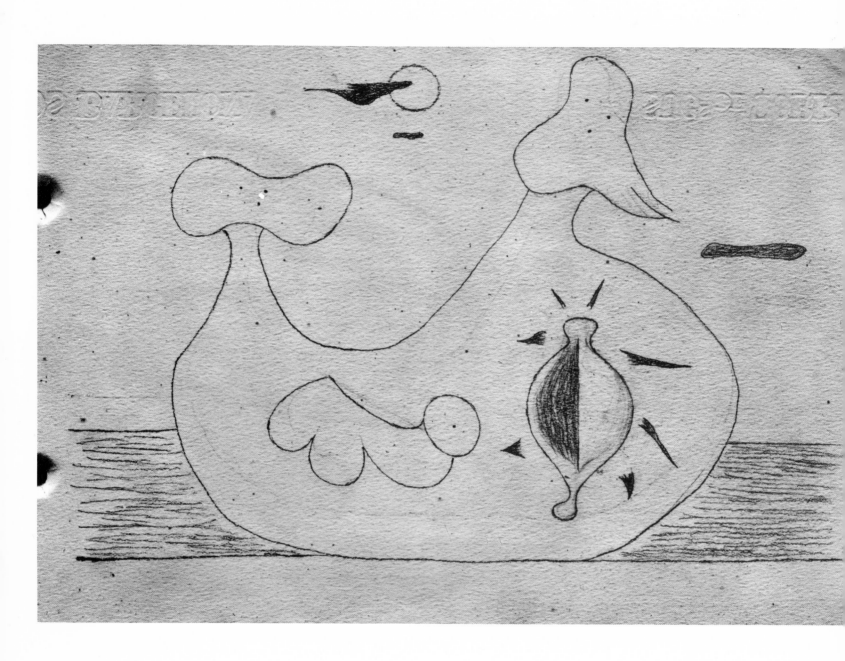

42

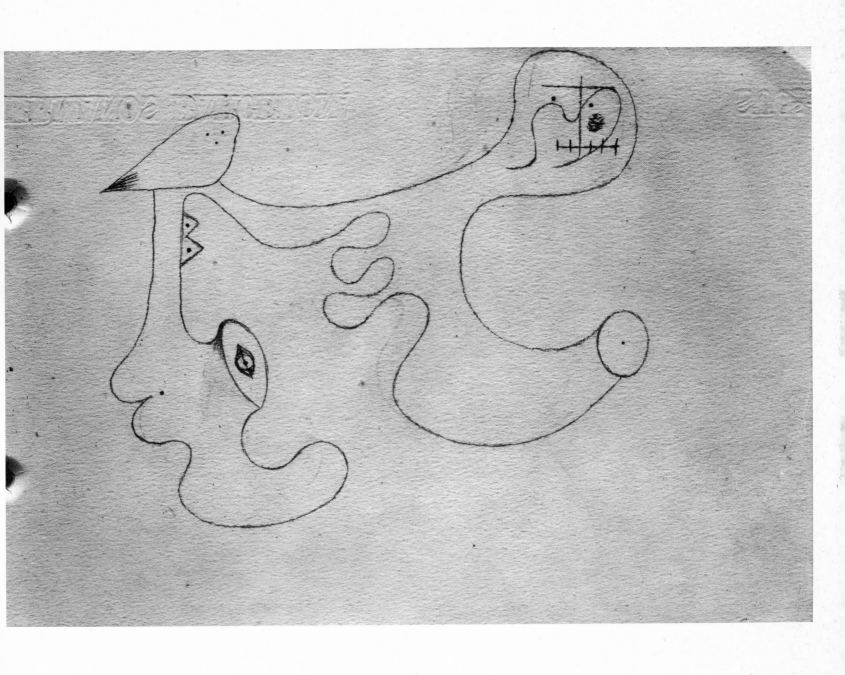

50

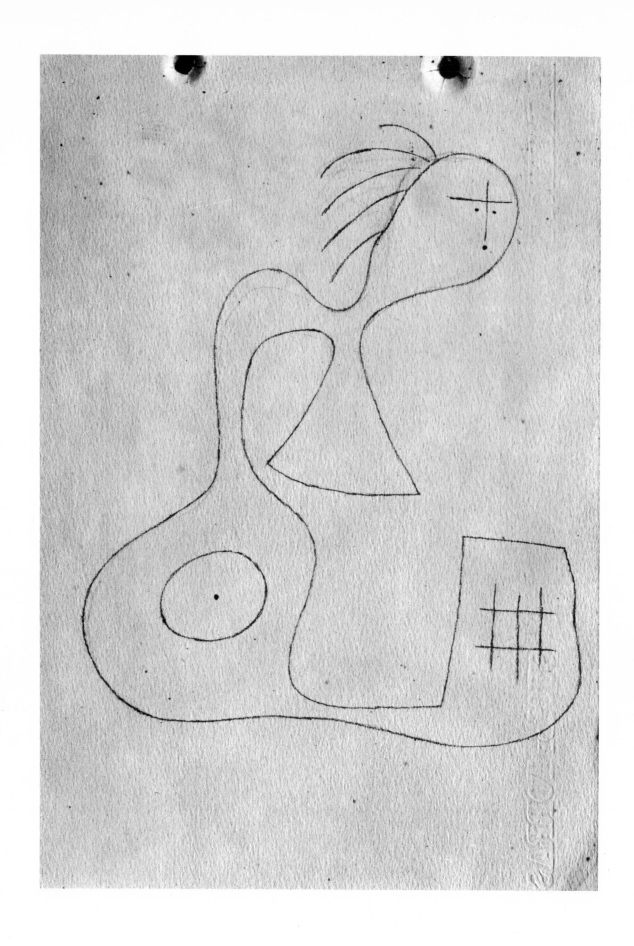

52

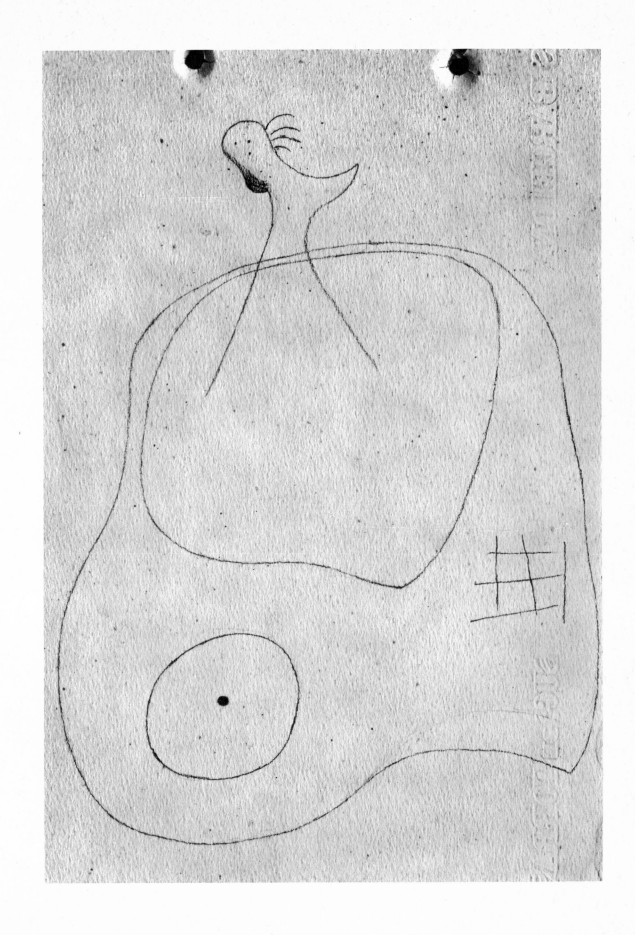

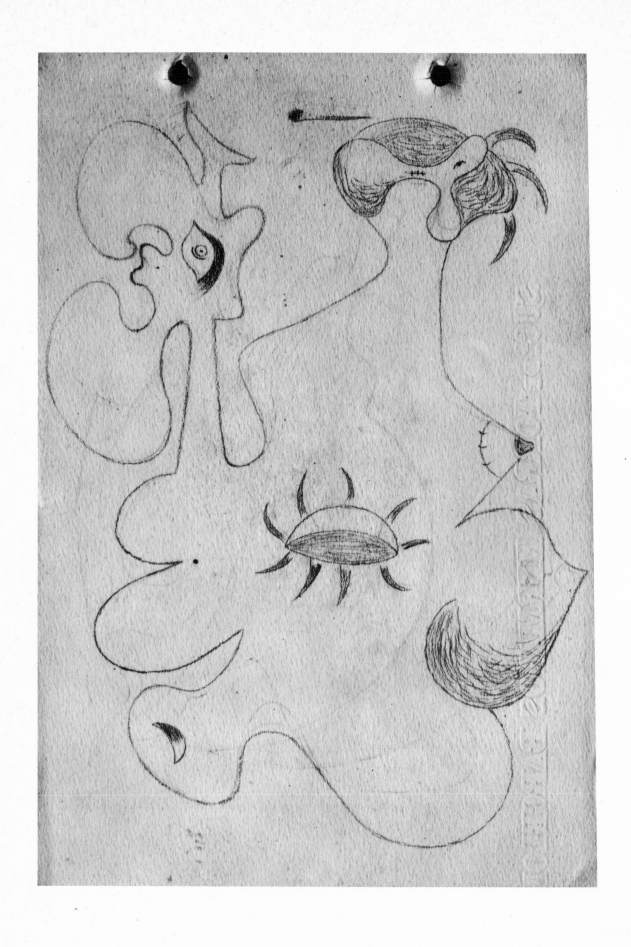

54

However, these drawings were never either studies for a painting or done after one. They are pure drawings. The best comparison is with the 1929 series of *Imaginary Portraits* rather than with the more fanciful, exuberant outlines of *Mrs. Mills. Queen Louise of Prussia* and the *Fornarina* also evoke the simplified shapes of the drawings and their style: triangles forming the lower half of the body, the overhanging bust. A few slightly earlier and later paintings are rather like the drawings, for instance one of the *Paintings* of 1930, a woman with a bird's head and fish's tail, her three hairs becoming hoofs, and the *Heads* of 1927; these paintings were done in one continuous movement and contain the minimum of internal detail. While the comparison between a drawing and a painting is seldom close, there are nevertheless precise parallels between the details of the painting and those of the drawing. It is almost as if the shapes in the drawings must either be discarded or kept in their entirety, not brought into contact with the swarming forms on the canvas where they risk being eclipsed. Even the simplest and most homogeneous canvases are more complex and dissociated than the drawings. For instance, in this drawing, which is rather like the famous *Dog Barking at the Moon*, all the elements—sky, earth, moon and toenail—are inscribed along a single stave, whereas in the painting they are bisected by the line of horizon. Among Miró's paintings, only the 1925-1927 series of *Circus Horses* (or *Lassos*) can really be used as an example of a shape formed by a single line. All the same, with the one, abstract line of the painting, Miró did not have to overcome the difficulties of conveying the complex in simple terms as he did in his zoomorphic drawings.

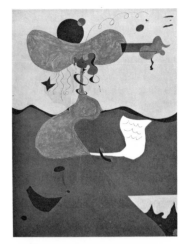

Portrait of Mrs. Mills in 1750 (after George Engleheart), 1929.

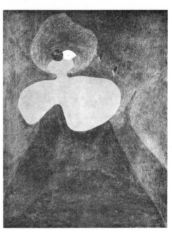

La Fornarina (after Raphael), 1929.

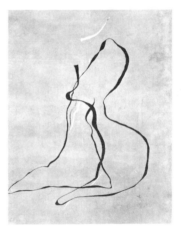

The Circus Horse (or Lasso), 1927.

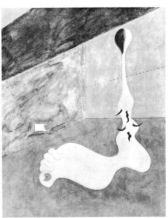

The Statue, 1925.

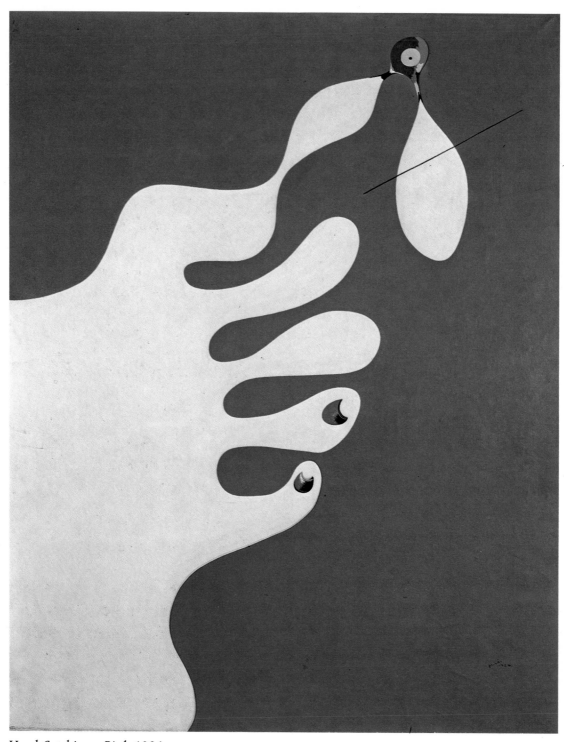

Hand Catching a Bird, 1926.

What drawings and paintings do have in common are the signs and patterns. A rectangle is suspended from the transverse lines piercing the neck like a harpoon; this is reminiscent of *Maternity*, in which the breasts and the rounded triangle of the belly are suspended from two intersecting lines. The shape of these splayed fingers, sinuous outflow of a sluggish river, is the shape of the foot in *The Statue* (1925) and the *Hand Catching a Bird* (1926). In these drawings, the phallus as a section of a column, the almond of the female sex organ, the checkerboard, the fixed star, the shooting star, the ladder and the toenail-crescent moon are all components of a fabulous alphabet invented to transcribe the simplest things in the world.

Nearly all Miró's complicated paintings originated with one or more drawings, especially paintings in which various shapes are combined. The painter makes use of a sort of diary consisting of brief notes, ideas and diagrams. Some of the drawings are actually preliminary models for the paintings, and the model itself often evolves from one drawing to another as he works it out. However, Miró rarely develops the model by means of progressive elaboration passing through a whole series of drawings. He does not work on preliminary studies for their own sake, but because he can visualize the painting through the drawing, and put it down on canvas more or less immediately.

However, for *Queen Louise of Prussia*, Miró worked through a whole series of documents. An advertisement for a diesel engine cut out of a magazine, with the emblem of some sort of bird attached to a square plate at the top. A subway ticket on which this outline is developed further. An angry rooster. An elongated oval. A head emerging from the oval like a leaf. An eye on the leaf-head. Then the oval beneath the head became a pair of curved, folded arms, like amphora handles, and two parallel lines completed the rest of the body before diverging to form a triangular dress. The overall shape of the woman began to stand out, and the plate to which the bird was attached, and which had disappeared, may have ended up as the curtain on the left. The color (black) of the curtain is suggested by hatching in the drawings, as until then the study was purely linear. When Miró began to contemplate a color scheme, he wrote at the top of the drawing:

> very concentrated
> pure in spirit
> no painting

and then at the lower right:

> but very rich in color
> glowing color
> very well painted

Two sets of guidelines, the contradiction between them being evident. Miró explained himself:

"I rectified the first annotation. Next day, maybe even the same day, I changed my mind; you can see that I used two different pencils. All the same, I didn't quite lose sight of the initial idea. I did a painting, but without the nuances of a painting and with none of the tricks of the trade!"

Pure in spirit! We must remember that Miró is thus referring not only to the purity of the line, which had to be kept from being tarnished by the color, but also to the purity of the color itself, which had to be kept up to the full glow of its natural presence. The four surfaces—right wall, back wall, floor and curtain, orange, yel-

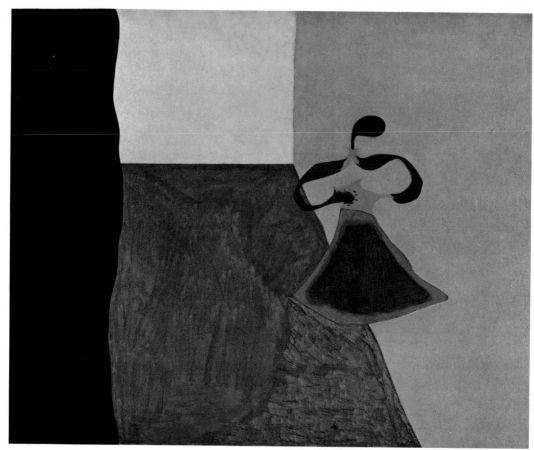

Queen Louise of Prussia, 1929.

*Preparatory drawings
for Queen
Louise of Prussia.*

58

low, brown and black—balance so perfectly that there is some danger of seeing the painting as an abstract composition from which the figure of the queen could be omitted. But wouldn't the canvas be empty without her?

So a line drawing can be elaborated on over a period of time, but color comes forth instantaneously, like the sun over the horizon.

In the mass of sketchbooks accumulated by Miró the colorist, there is very little color, mainly because he did not need to elaborate it. The first mention of color is usually an abbreviated note ("g.b.r.") as in these drawings just described, or else he mentions it as part of the program he has laid down—*very rich in color*—as in *Queen Louise*. Even when a preliminary drawing is still in its early stages, color is never very far behind, but Miró has no need to try it out, for it will surge up when the time comes. A few of the sketches in the small notebook entitled *The Magic of Color* ended up as canvases, but Miró rarely prepares his color scheme so thoroughly. In fact, "prepares" is a big word for such a simple first plan.

Painting (or Mediterranean Landscape), 1930.

Painting, 1930.

Painting, 1930.

Painting, 1930.

Mediterranean landscape. Small notebook.

"Pasted leaves." Small notebook.

"The Magic of Color." Small notebook.

Mountain. Small notebook.

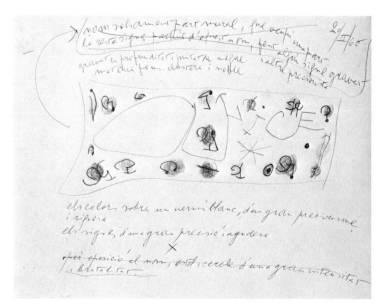

Sketch for Alicia, 20/II/60.

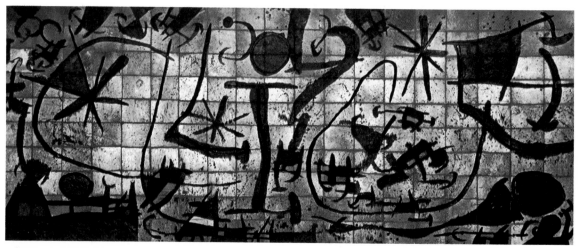

Alicia. Ceramic mural, 1965-1967.

The notebook entitled *Guggenheim Notebook* serves a different purpose, of course, and contains detailed elaborations on color schemes.

"I took the name Alicia as a starting point for the Guggenheim mural, Alice Guggenheim, in memory of the woman who founded the museum. You can see the letters of her first name scattered throughout this sketch. I did it in color, which is unusual for me; the color indications were intended for Artigas, the ceramist, who had to prepare his enamels.

"We wanted to do a large mural divided into squares, then we went on to handle it as a unified surface. I started from a very vague plan, as usual. Then I thought a long while about what I wanted to do. In the end, I did the line patterning in one fell swoop, with a big broom. I draw very freely, and it's pretty dangerous; you can't go back on it, either it works or it doesn't.

"And you have to work in gray, without color, as the colors don't show until they're fired. While you're working, you don't know what the end-product is going to be like, you're completely in the dark."

"This…"

As he turns to another drawing, we recognize it at once as a sketch for *The Hunter* (or *Catalan Landscape*) of 1923-1924.

The notebooks of preliminary drawings that we are now going to look through date from 1924 to 1926. They are the most exciting of all, because they are revelatory records of the moment when truth becomes poetry.

On the upper left side of one drawing Miró had written "Catalan Peasant" and at the bottom "Catalan Landscape" (the sheet being marked with the cross which indicates that the projected picture had been executed). The peasant is still

Sketch for Catalan Landscape (The Hunter).

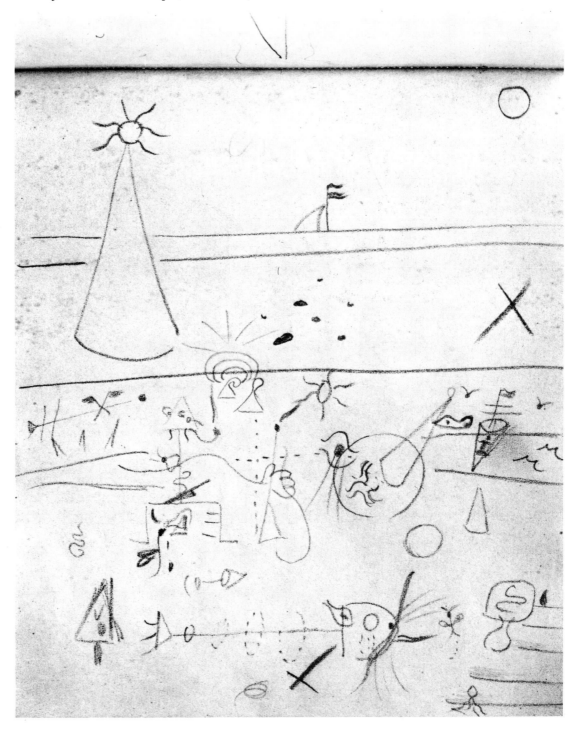

drawn realistically; in a stylized form, he became the *Smoker* of 1925. He is sucking his pipe, and holds a hare in one hand and a smoking gun in the other; his sexual organs are the only details shown on his body. Beside him are the symbols of the landscape, a carob tree represented by a circle from which its leafy branch emerges. On the right side of the drawing, Miró drew a few stock shapes with which he was experimenting: a *passionara* flower, a fly destined to be eaten by a sardine.

The *Catalan Landscape* or *The Hunter* is one of Miró's first major poetic canvases, following the *Tilled Field* to which it is closely akin; the mutation of the detailed realism found in *The Farm* has been completed.

The other drawing is very like the painting; all the details are there in symbolic form, once you can decipher the signs. Miró explained them.

"This is the carob tree, the characteristic tree of Montroig... There's the sea in the background, an eye, an egg-shaped sun with its rays... The Catalan peasant has become a triangle with an ear, eye, pipe, the hairs of his beard and a hand. This is a *barretina*, the Spanish peasant headdress, you can hardly see it. And the man's heart, entrails and sexual organs. I've shown the Toulouse-Rabat airplane on the left; it used to fly past once a week. In the painting, I showed it by a propeller, a ladder and the French and Catalan flags. You can see the Paris-Barcelona axis again, and the ladder, which fascinated me. A sea and one boat in the distance, and, in the very foreground, a sardine with tail and whiskers gobbling up a fly. I wrote *Sard* in big letters on the painting, and some people thought it meant sardana, which is much more romantic! But it actually stands for sardine, you can't miss

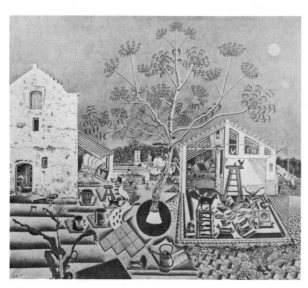

The Farm, 1921-1922.

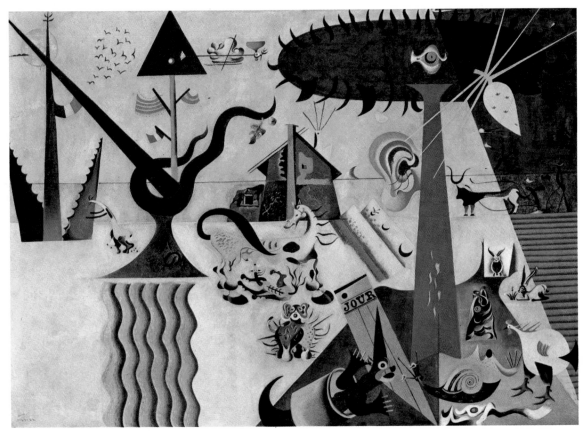

The Tilled Field, 1923-1924.

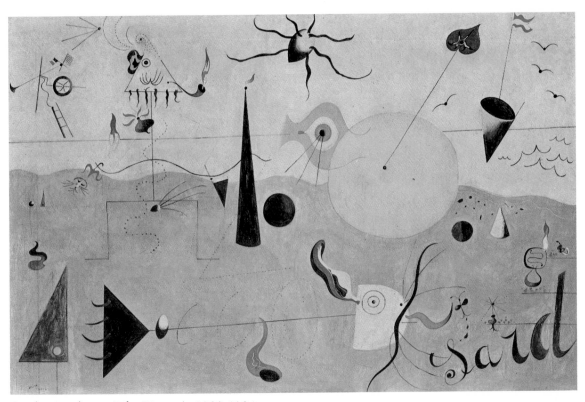

Catalan Landscape (The Hunter), 1923-1924.

The Smoker, 1925.

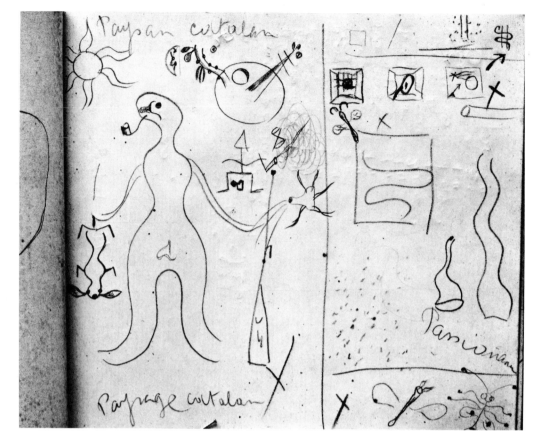

"Catalan peasant — Catalan landscape." Drawing.

it! A broiler waiting for the rabbit, flames and a pimento on the right. And waves and seagulls. You see, the outline of the sardine echoes the horizon line. I've always been very much concerned with pictorial construction, not just poetic associations, and that's where I differed from the Surrealists."

Though the drawing and painting are very similar, the painting is simpler and more open, and elements that seem to be below sea level in the drawings are raised in the painting and silhouetted against the sky, as if the painting were an amalgam of two superimposed drawings.

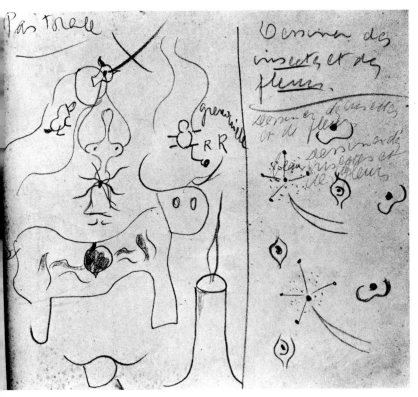

Pastorale." Page from a notebook.

"Tilled field (the house)." Page from a notebook.

On another sheet Miró, as often, mingled shapes that were later shared between various paintings, and put figurative shapes next to their pictorial transcriptions. Here we can see the house and, in the foreground, the tall cylinder for the *Tilled Field*, a ladder, and the outlines for *Pastorale*, with little figures gesticulating from the top of a tree and balancing at the end of a sinuous line. These were not used in the painting, but the circles, arcs and right angles were, and the bull, elaborated in another drawing, was already sketched in. We can also see an ear of corn, a feather, and Miró's notes on what he

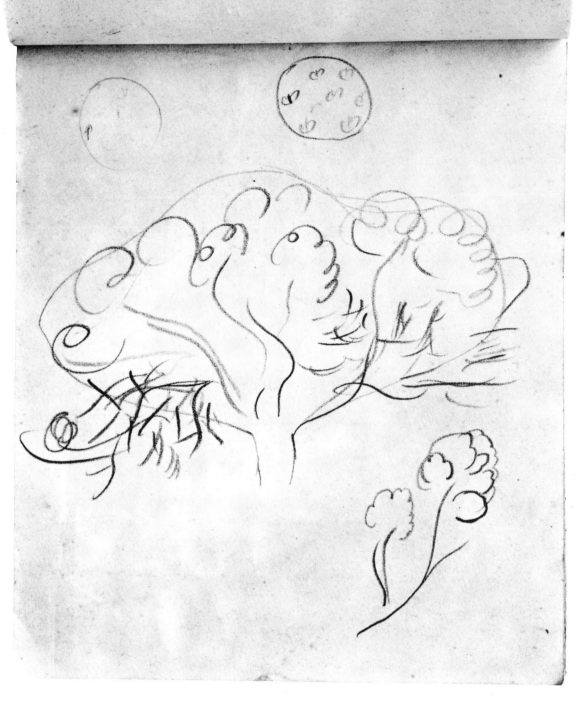

Carob tree. Page from a notebook.

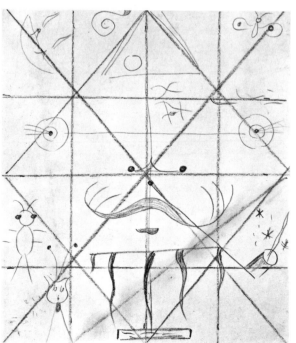

Preparatory drawing for
Catalan Peasant's Head.

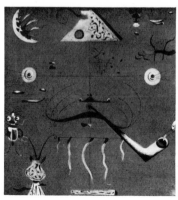

Catalan Peasant's Head,
1924-1925.

68

intended to do—draw *insects* and *flowers*—with a few brief instructions.

In another drawing, Miró sketched a carob tree in all its glory and, above it, the circle that became its symbol.

Miró's paintings can be simpler or more elaborate than the drawings on which they are based, but usually the whole invention is already contained in the first, if not the only, preliminary sketch. This squared drawing corresponds in every detail to the *Catalan Peasant's Head*. A few details were eliminated in the painting *The Trap*,

Preparatory drawing for The Trap.

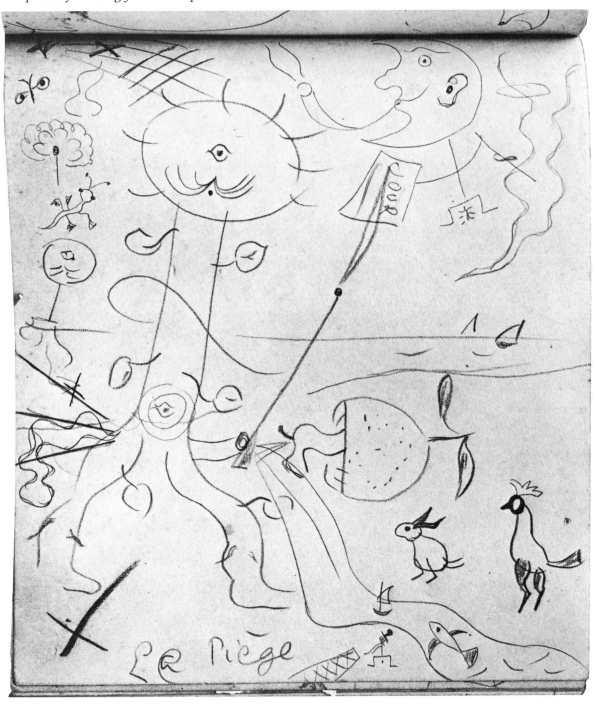

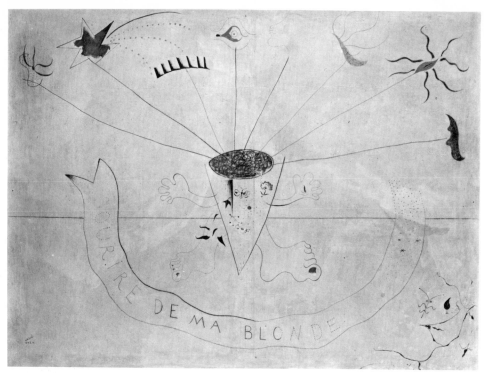

Smile of my Blond, 1924.

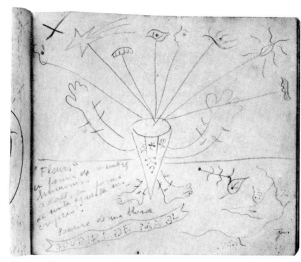

Sketch for Smile of my Blond.

but Miró took up the basic components of the drawing, such as the hunter camouflaged as a leafy tree with a phallus, the dog hidden in a lemon, the sea and the sails. The drawing for *The Smile of My Blond* looks more like a program-sketch than the final design, since Miró wrote on it *"Flowers in the form of human limbs"* and other indications; yet every detail of the canvas is anticipated, though in the painting the weird,

heraldic figure is more central, and the ribbon bearing the French title more widely unfurled. But everything can be found in the drawing: leaves, butterfly, bunch of grapes and the vase-like torso from which hands and feet emerge on either side.

Then there are the flowers in the vase—the ear, a shooting star, teeth, an eye, a profile, hair, sexual organs surrounded by hair, and breasts.

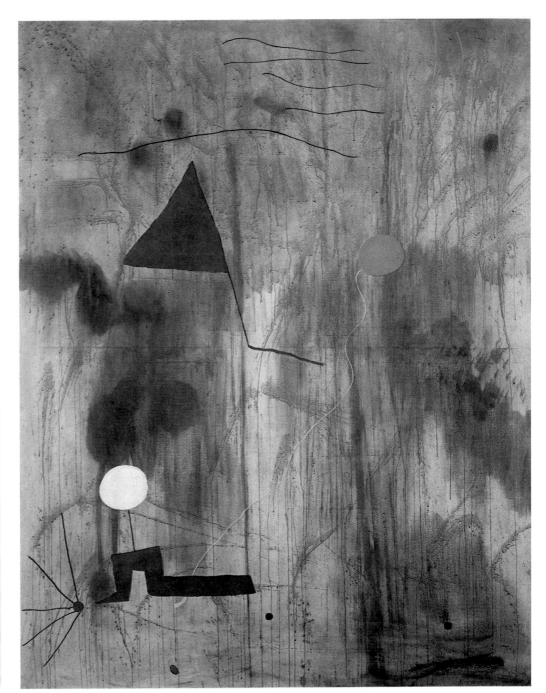

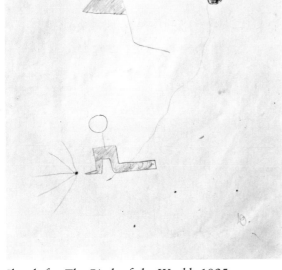

Sketch for The Birth of the World, 1925. *The Birth of the World, 1925.*

In the painting *The Sign of Death* Miró retained nothing of the drawing except the mysterious figure 133, enclosed it in a sun, and put the title in an elongated oval. The ant became a smaller disc, like a consecutive image of the sun, which can be pinned down no more than death itself. In fact, the painting is so simplified that it could only have sprung from an integral vision. The same holds true for the drawing for *The Birth of the World*, of which the painting is no more than a colored reproduction. However, even if a drawing contains all the elements of the painting, as does *Dog Barking at the Moon* in which even the small cloud over the ladder already appears in the preliminary sketch, the change of title and the elimination of the phrases written on the drawing modify the scale and mood of the painting.

"I had done a sort of comic strip. *I don't give a damn, you know*: that's what the moon is saying as the dog barks at it: *Boub boub...* I crossed out on the actual drawing anything I wasn't keeping in the painting. In fact, I'd called it *Puppy Yapping at the Moon*. The dog in the drawing is smaller than the dog in the canvas. He's only a puppy!"

Miró stopped talking, lost in memory.

"How did I think up my drawings and my ideas for paintings? Well, I'd come home to my Paris studio in Rue Blomet at night, I'd go to bed, and sometimes I hadn't had any supper. I

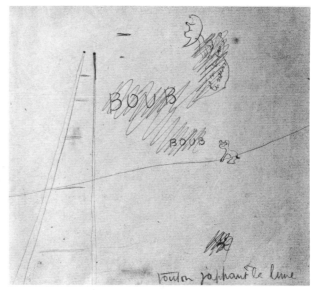

"Puppy yapping at the moon."
Sketch for Dog Barking at the Moon.

Dog Barking at the Moon, 1926.

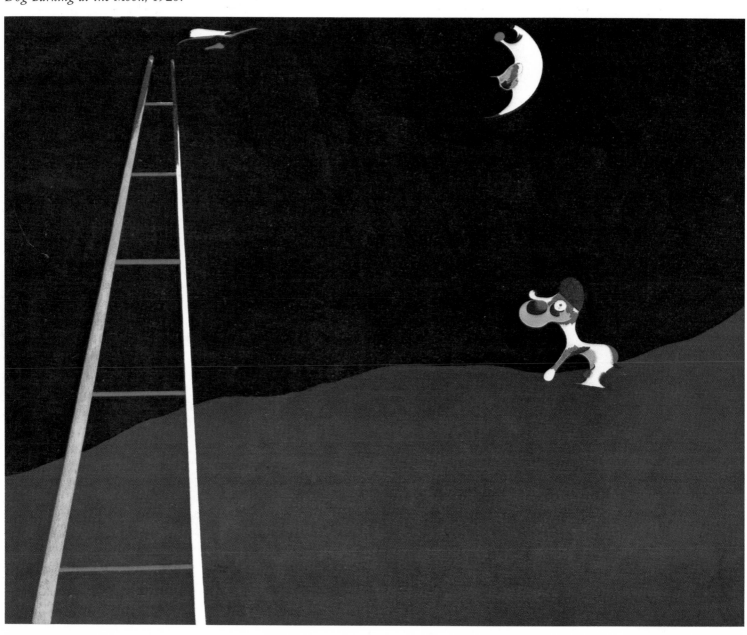

saw things, and I jotted them down in a note-book. I saw shapes in the chinks in the walls, and shapes on the ceiling, mainly on the ceiling... It certainly wasn't a very luxurious studio, but it was neat and clean, I used to tidy it every day. But you should have seen how my neighbor André Masson lived!"

He looked at a page on which he had listed the objects he already had in his Paris studio and those he wanted to get. "Here I put down a small pitcher, a Majorcan whistle and a gourd on the whatnot in the hall... As you can see, I've got all those things here... I also had a trunk, for traveling and for my suits and canvases. I used it as furniture, and put a cloth over it... I wanted to put a bowl of goldfish on it, but I never did—apparently that would be unlucky... I noted down the things I wanted. A map of Europe, a box to keep matches in, a slate on which to write down my appointments; not that I had very many. I also had some chairs that I'd picked up for five or ten francs at the Paris flea market, a rush mat I got at the Bazar de l'Hôtel-de-Ville, some small flags and shells... My uncle gave me some things that I wanted to hang on the wall in the shape of a constellation—already!—and some toys made of palm leaves that I still have."

The two drawings we looked at next were for *The Siesta*. They are a striking illustration of the radical—and mysterious—way in which his figurative notation was transmuted into poetic abstraction, and a rather crowded array of anecdotal elements into symbols all the more effective for being used sparingly. Miró talked about the first drawing, a descriptive and detailed one:

"Yes, it's a complete scene with all the accessories. There's the sea, a sail, a woman swimming, the peaks of a mountain. The sun darting its tongue-like rays, a bird in a cloud, an airplane. The first horizontal (marking the edge of the beach) is bisected by a ring of dancers—this time it really is the sardana! A donkey tethered to a tree is playing ball with a rabbit. Here's a ladder with a bird perched on one rung, some butterflies, a pitcher. In the foreground I drew a concertina, a two-spouted jug (*porrón*),

Sketch for The Siesta.

73

grass, flowers, an apple, a bunch of grapes (for dessert!). You can see the house, with cracks in the wall, on which I put a sundial showing noon. A woman is lying in front of it asleep, dreaming. Some figures are outlined within a cloud, against the sky. The woman's daughter, her mother, maybe her lover? No, in her dream she is seeing herself with her child!"

None of the supplementary details appear in the second drawing, apart from the woman swimming, a wave, the outline of the mountains, and the sun—all much more schematic. The woman has undergone an extraordinary metamorphosis: she makes one with the house, her mermaid-like body fused with the square into a single shape from which the arrow of the sundial pointing to the number 12 emerges. The number is the only inscription on the sky.

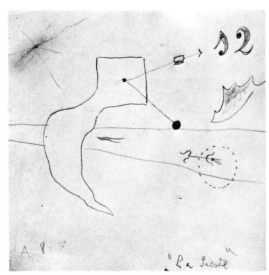

Sketch for The Siesta.

The Siesta, 1925.

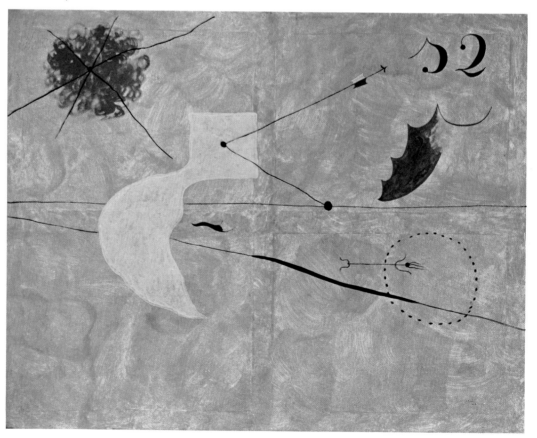

74

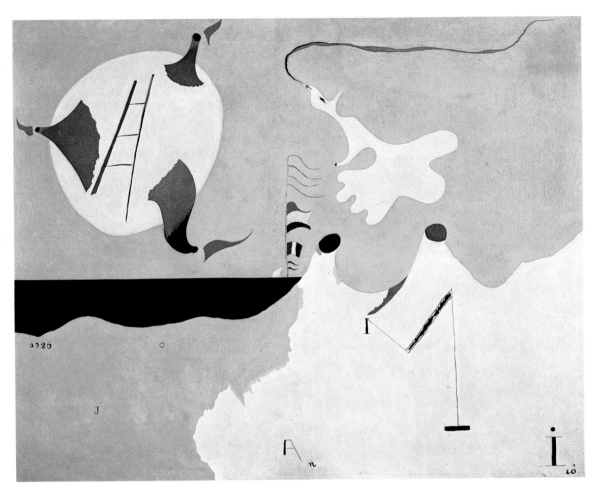

Landscape
(or The Grasshopper), 1926.

"The woman's eye is looking at the number. It's noon, lunchtime, siesta time. I wrote down the size and title of the canvas on this drawing: size 80—a standard format—and the background color: A = *azul* (i.e. blue)."

The Grasshopper does not leap from a figurative drawing to an abstract canvas but from reality to myth. In the 1926 painting, is the winged animal spitting out a long ribbon and leaping through the sky toward the sun, above the cone of volcanoes overlooking the sea, really a grasshopper?

"Yes, my starting point really was a grasshopper. The animal in the top left hand corner of the drawing with the line of ground and the sea is actually a grasshopper. The rest of the

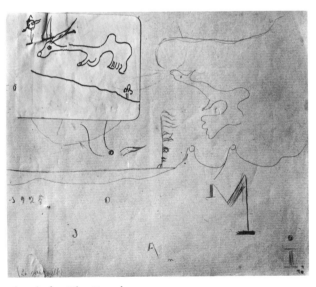

Sketch for The Grasshopper.

sheet is almost exactly like the painting—mountains, the sea, the animal's flying jump and its metamorphosis. Even the scattered letters of my name, Joan Miró, are already there in the drawing, but for the painting I added the sun on which the inverted shapes of the mountains are outlined, and the ladder of escape. That's a grasshopper all right! I was in the country round Montroig, and I studied crickets and all sorts of insects..."

The Montroig insects! One of Miró's 1924-1925 canvases is called *Dialogue of Insects* and his

Sketches of insects.

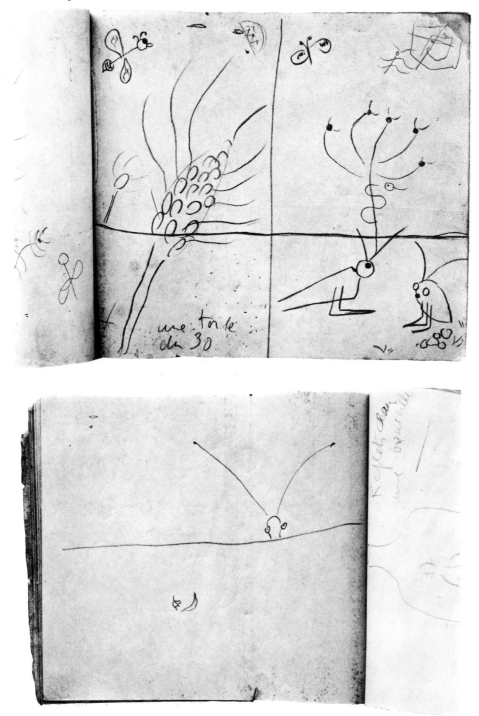

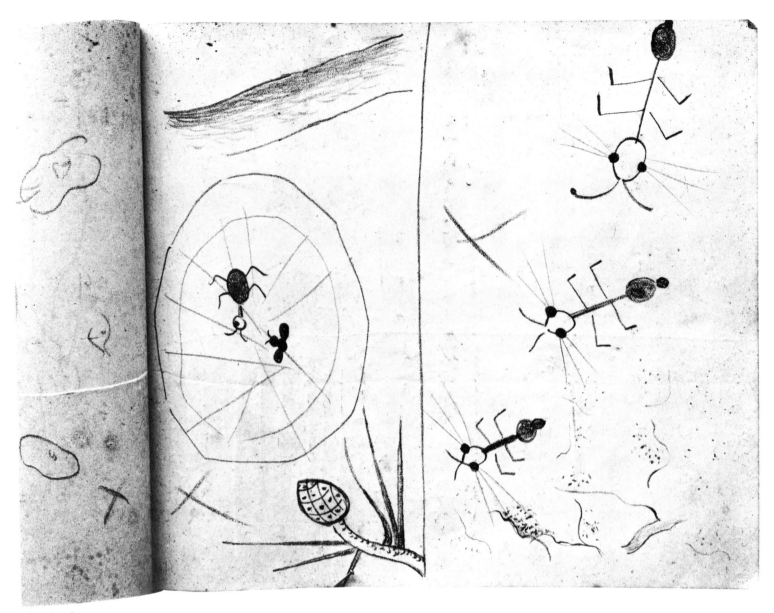

Sketch of insects.

notebooks swarm with drawings of insects. But the ones reproduced here have very little to do with the actual painting, for they crop up all over the place. The drawing on page 76 includes a large ear of wheat on the left (did it become the tree on the canvas?) and, on the right, a grasshopper and cricket confabulating, a tiny snake coiled round a tree and a spider catching a fly. On the other sheet are Miró's studies for a spider, its web, a fly and ants.

Then comes this striking drawing, which was not followed up by a picture: looming above the horizon line, into empty space, the tall, arching antennae and the protuberant eyes of an ant—bringing to mind the one that made a fleeting appearance on the drawing for *The Sign of Death*.

Again the transition from figurative notation to abstract signwork: such was the prevailing trend of these years.

The first drawing for *Person Throwing a Stone at a Bird* contains an academic nude, a classic discus-thrower, really, for the arm movement is faithfully reproduced. In the other drawing, which is very close to the 1926 painting, Miró reduced the figure to a small, round head with a bird's eye stuck to a leg ending in an enormous foot like that of *The Statue*. The arm movement and the trajectory of the stone have become the intersection of two slanting axes. In the painting, the leg swells like a torso, the two volcanic cones of the landscape are stressed, and the bird is simplified even further, but those are the only changes.

Two sketches for
Person Throwing a Stone at a Bird.

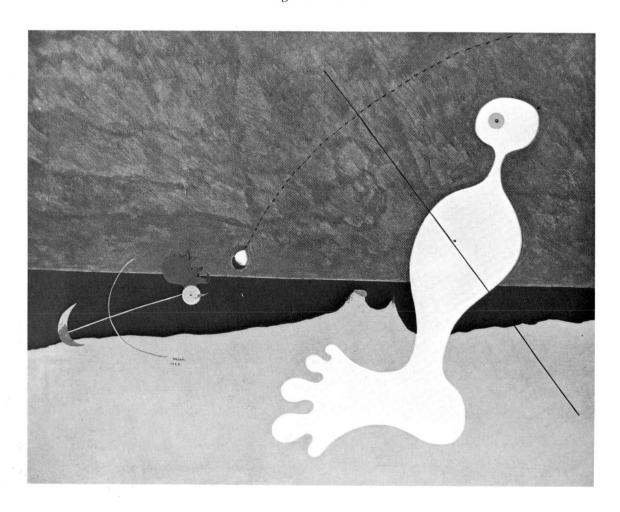

Person Throwing
a Stone
at a Bird, 1926.

The same process occurred in the two drawings for *Maternity*. Miró first drew the woman realistically and only suggested the symbolic form that was later elaborated and replaced her in the painting. In fact, she ended up scattered to the four corners of the canvas. Along one axis her head (a black cowl with a few hairs waving on top) is linked with her belly and sexual organs (the large triangle with one curving side). Bisecting it is a second axial line and at its extremities are the breasts, one in front view from which dangles a female child, the other in side view from which dangles a male child. In the middle of the first axis is a wriggling, worm-like form. All the details of the drawing were retained in the painting, down to the small clouds, though Miró widened the angle between the two axes a bit and eliminated the figure

Two sketches for Maternity.

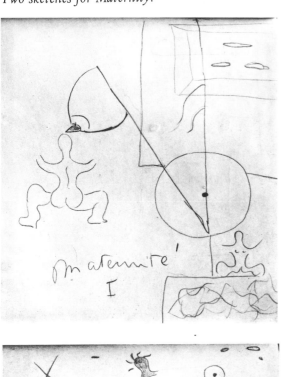

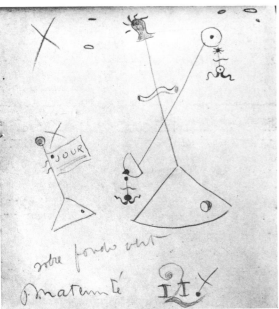

Maternity, 1924.

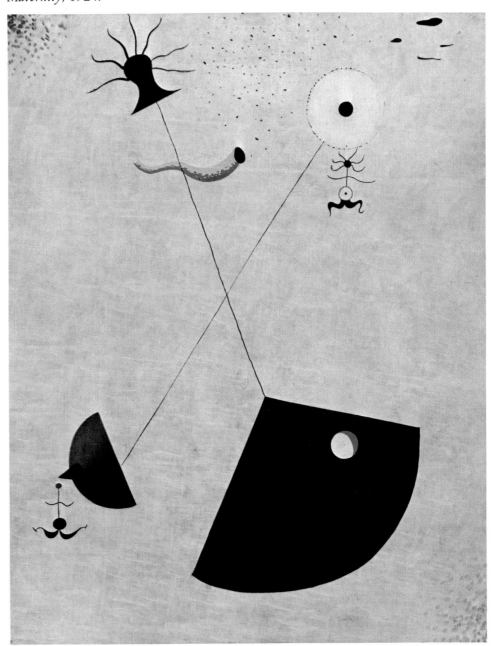

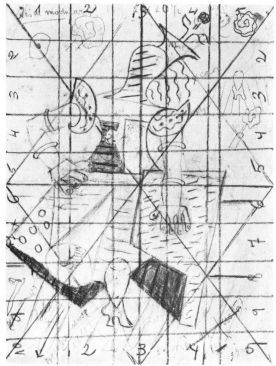

*Squared preparatory drawing
for Spanish Dancer.*

Two sketches for Spanish Dancer.

bearing the banner inscribed *Jour* on the left; this incompatible figure seems to belong to another version of the painting.

In the case of the drawings for the *Spanish Dancer*, things were different.

"I did a large painting in Rue Blomet in 1924. Here you see the two drawings I started out from. The third drawing is carefully squared; I cross-ruled the paper and numbered each division. Yes, I worked like that for a short time."

But the painting is very unlike the drawings. In the first two, Miró drew the head realistically, and there is hardly a sign of the stylized helmet it later became, which was only elaborated in the squared drawing. The painting and drawings have virtually nothing in common but the

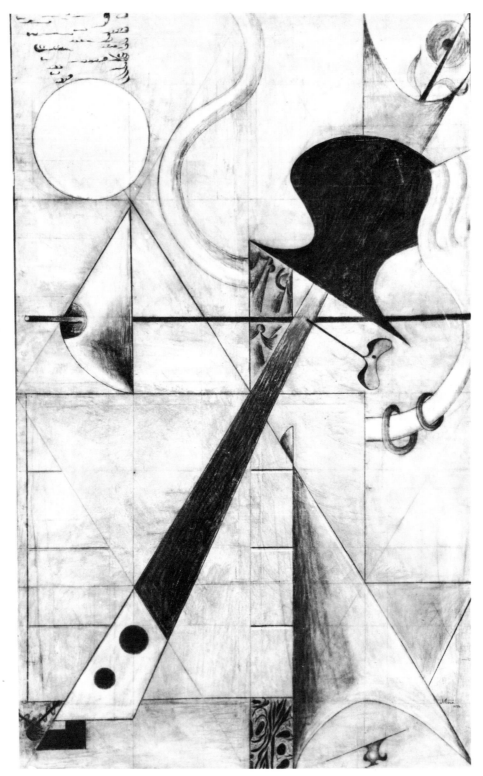

Spanish Dancer, 1924.

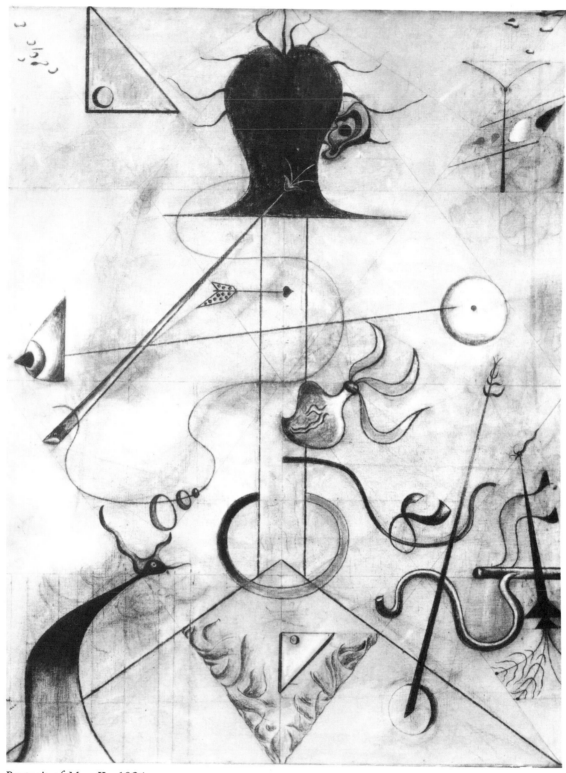

Portrait of Mrs. K., 1924.

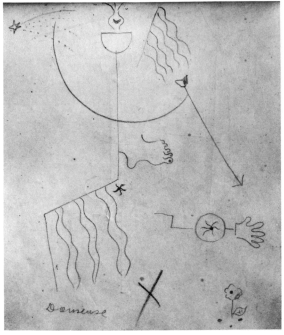

Two sketches for Dancer.

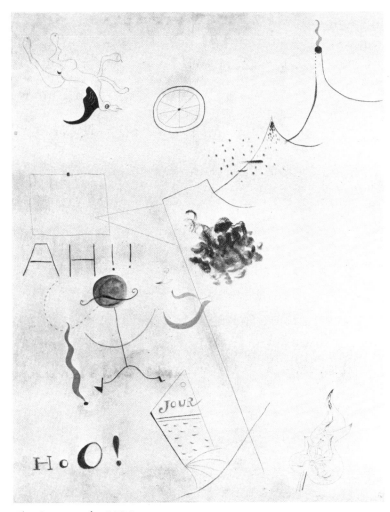

The Somersault, 1924.

rhythm of the diagonal raised from the lower left hand corner to the top right hand corner. However, the axis from which the breasts are suspended, one sideways, one head-on, as in *Maternity,* appears in the painting only. Two other drawings, *Dancer* and *For the Dancer,* include the balancing axes characteristic of *Maternity* (and also of the *Portrait of Mrs. K.*), which cannot be found in the first drawings, but the other elements of those two drawings are very unlike those of the actual 1924 painting. Miró juggles his shapes and signs and hesitates before positioning them for good on the canvas.

"This..."

This squared drawing is of course a sketch for *The Harlequin's Carnival* of 1924-1925.

Unlike the sketches for *The Hunter* and *The Trap*, this drawing is simpler and less detailed than the painting. On the left, we can see the tall, moustached Harlequin, looking more like a Catalan peasant than he does in the actual painting. The ladder equipped with an ear is already there, as are the rooster, the table, the

Preparatory drawing for The Harlequin's Carnival.

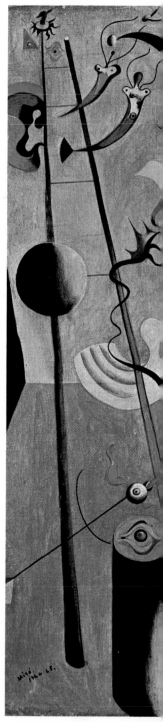

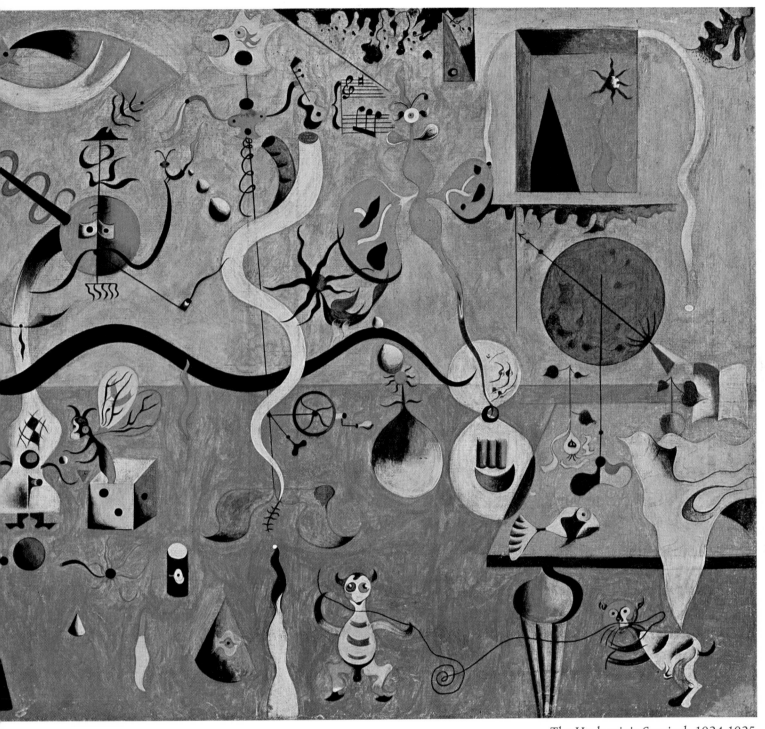

The Harlequin's Carnival, 1924-1925.

planisphere, the window opening on to a tree-triangle, flame and sun, the components of *The Hunter*. The drawing also contains the central, sinuous line of the painting and the cats playing with a ball of wool. Besides a good many minor additions, Miró also included in the painting a large, guitar-playing butterfly symmetrical to Harlequin; the drawing only contains the guitar.

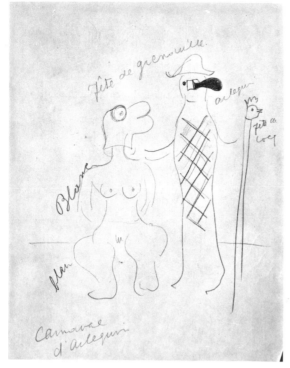

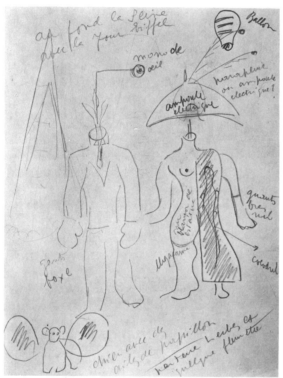

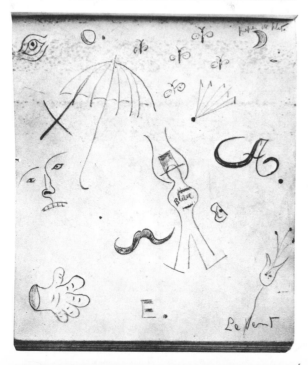

Miró wrote "Carnival of Harlequin" at the bottom of another drawing, which does, in fact, contain a perfectly recognizable Harlequin holding a long cane with a rooster's head, but he is not really the Harlequin of Miró's world. The woman with the frog's head reappears neither in the canvas nor anywhere else, in spite of the color notations implying that she is to be elaborated.

Miró next showed us a weird drawing which is in no way related to the painting except for the dog with butterfly wings, an eminently suitable playmate for the cats figuring in *The Harlequin's Carnival*. Miró told us that they did in fact derive from the same source, his plans for illustrating a book by Robert Desnos which never saw the light.

"This is a man with a plant sticking out of his collar instead of a head. Beside him is a woman with an umbrella for a head. There's a small balloon at the top, and the Eiffel Tower. On the drawing I wrote: 'In the background the Seine with the Eiffel Tower.' It's all pretty odd; I mean, why is the man wearing boxing gloves? Everything is ambiguous. The umbrella could end up as a light bulb, and the eye might really be a monocle. Half the woman's body is a classical nude study (I wrote on it: 'White as a statue'), and the other half is a crocodile! But I never made anything out of it."

What might have been: all the signs available to Miró, all the signs he has devised and stored up...

Yet take the drawing for *The Wind*, in which the boxing gloves and umbrella reappear, together with a moustached man in a top hat, the letter A and an ear of grain. This became a painting so faithful to the original, floating design that even the silver foil moon of the

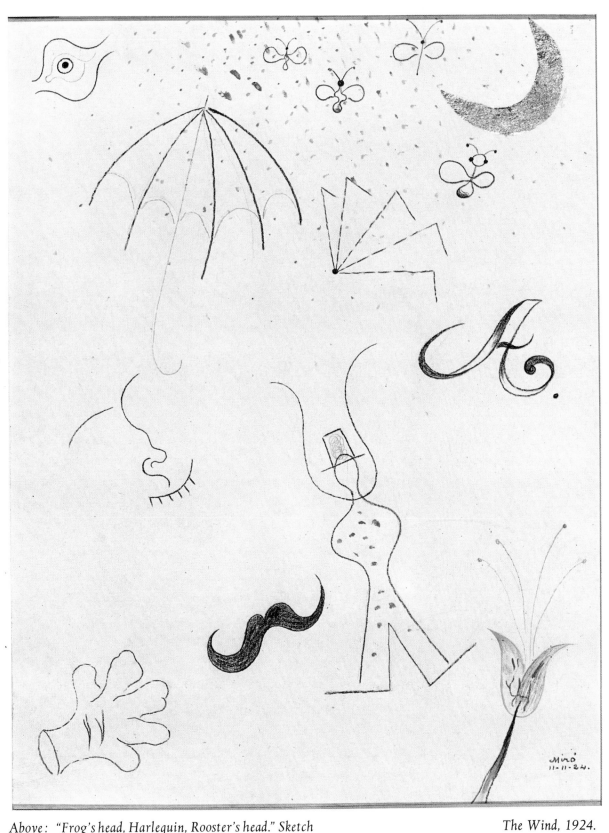

Above: *"Frog's head, Harlequin, Rooster's head." Sketch for The Harlequin's Carnival.*
Center: *"In the background the Seine and the Eiffel Tower." Sketch for an illustration for a book by Robert Desnos.*
Below: *Sketch for The Wind.*

The Wind, 1924.

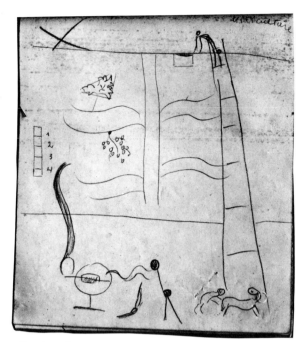

Sketches for two pictures never painted:
"Viticulture" and "Toys."

painting is already annotated *pepel de plata* in the drawing.

What could have been: all the paintings Miró planned but never did. These drawings are even titled—*Matador's Toast, In Memory of a Poem, Woman on the Beach, Viticulture.* There are also paintings that have been done but must be redone, because their themes are constant, sub-

Sketch for Woman on the Beach.

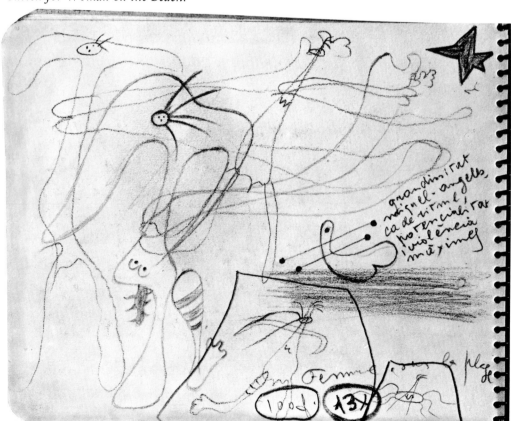

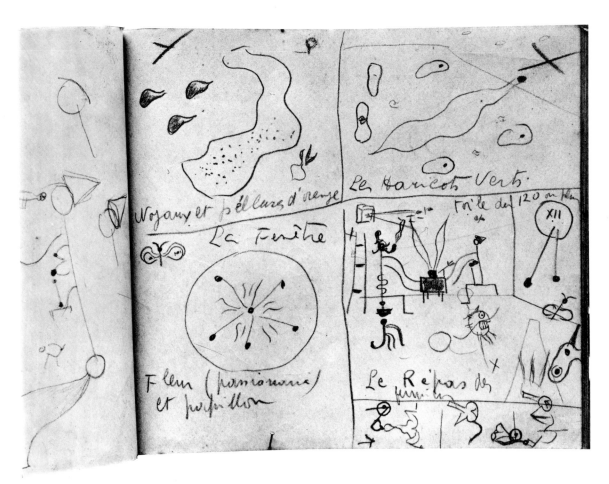

Page of sketches for The Farmers' Meal.

jects that cannot be exhausted pictorially no matter how often they reappear.

We examined the drawing for *The Farmers' Meal.*

"I did a small canvas after this drawing in 1935 (75 × 106 centimeters), though I'd written on it: size 120 canvas or bigger... I still mean to do a big painting of it some time. There are many elements of the canvas here: the donkey's head, the dog, the steaming pot, the table, the farmer's wife, the farmer with his pipe and *barretina*. I did studies for stringbeans, orange peels and a passion-flower on the same piece of paper, beside the drawing. I've often thought about the subject; I did a very schematic canvas in 1925 without much in common with this one

except the angle of the table and two spindly figures. And I still want to do the large canvas. There's no such thing as time."

The Farmers' Meal, 1935.

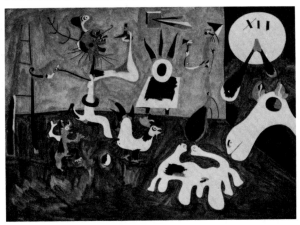

Two drawings for Lovers, 1925.

Embracing lovers. Drawing, 16.8.42.

Another recurrent, inexhaustible theme is that of embracing lovers, kissing couples. There are several ideas for painting in one drawing on which the kiss is shown in its simplest symbolic form as an hourglass with the waist stressed,

Drawing on the theme of adultery.

and pubic hair in the shape of a star. The 1924 painting echoes the drawing in every detail. Another drawing, with 30 F. written on it (i.e. size 30 canvas), was the model for a 1925 oil painting. Another represents love-making, and is really a more explicit version of a canvas done the same year in which as yet separated organs are substituted for the nebulous mingling of bodies. All these elements come together in this 1942 drawing of a kiss developing into a sort of duck's bill (the erect phallus), pulsing female sexual organs, and an elongated oval uniting the lovers.

The elongated oval, which occasionally takes on the overtones of a phallic symbol, reappears in a whole series of 1940 drawings, aptly entitled *Lovers*, in which the partners, seen here as spindly and vertical, are shown approaching each other, about to kiss, and linked at the top of the wide curve formed by their bodies. These could be considered companion pieces for the "Figures in the Night" of the same period, though the symbolic suggestion of sexual organs in the latter is rather more discreet.

91

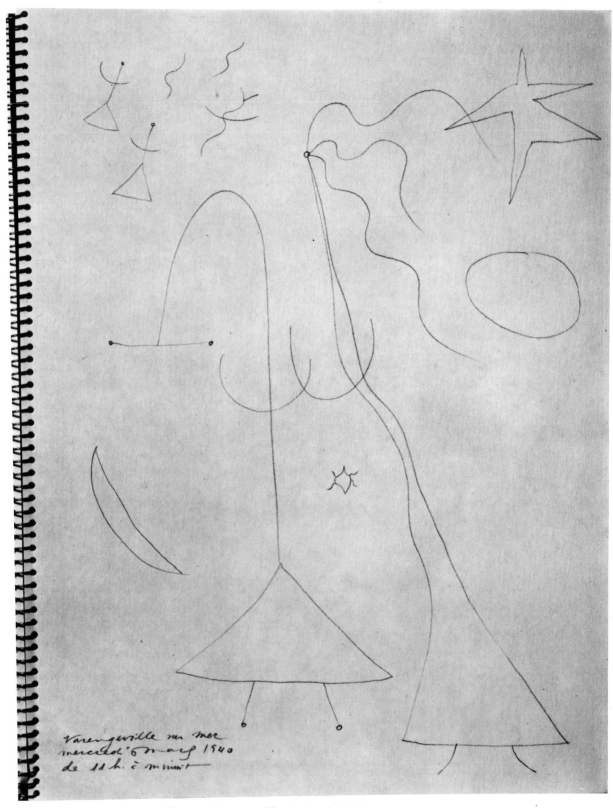

Study sheet on the theme of lovers. Varengeville, 6 March 1940.

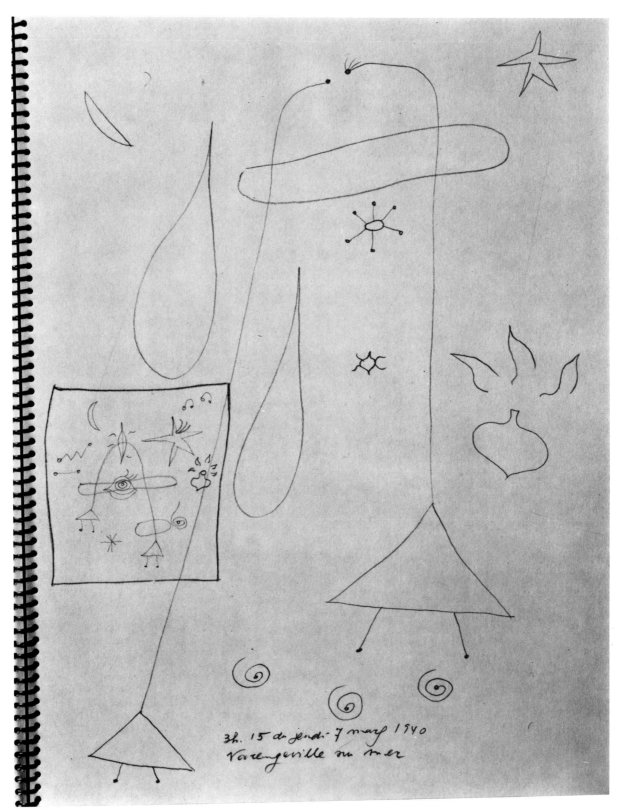

Study sheet on the theme of lovers. Varengeville, 7 March 1940.

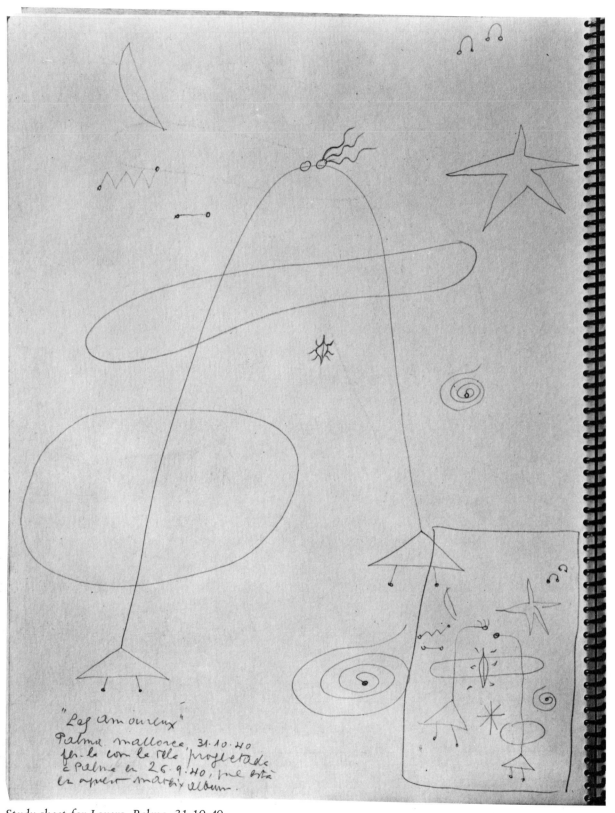

"Les amoureux"
Palma mallorca, 31.10.40
per la com la tela projetada
a Palma en 26.9.40, que està
en aquest mateix àlbum.

Study sheet for Lovers. Palma, 31.10.40.

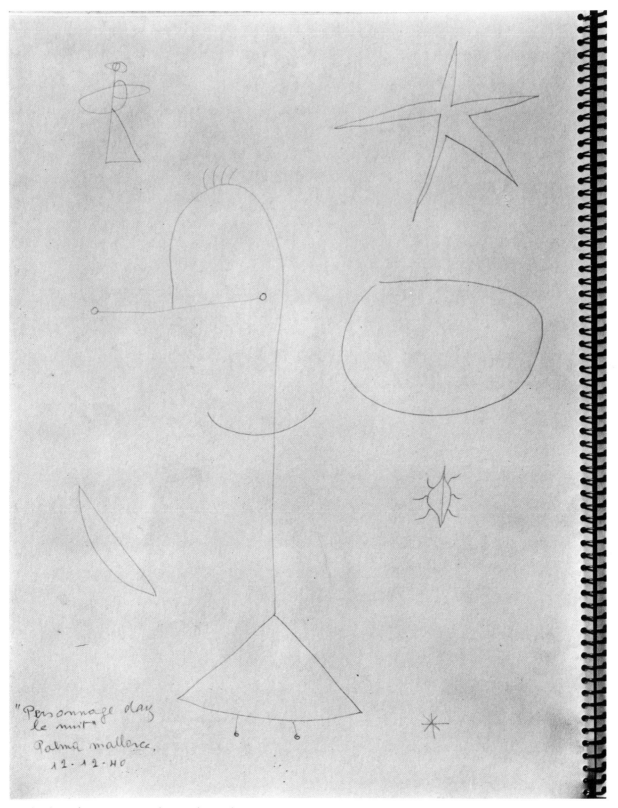

"Personnage dans
la nuit"
Palma mallorca,
12.12.40

Study sheet for Figures in the Night. Palma, 12.12.40.

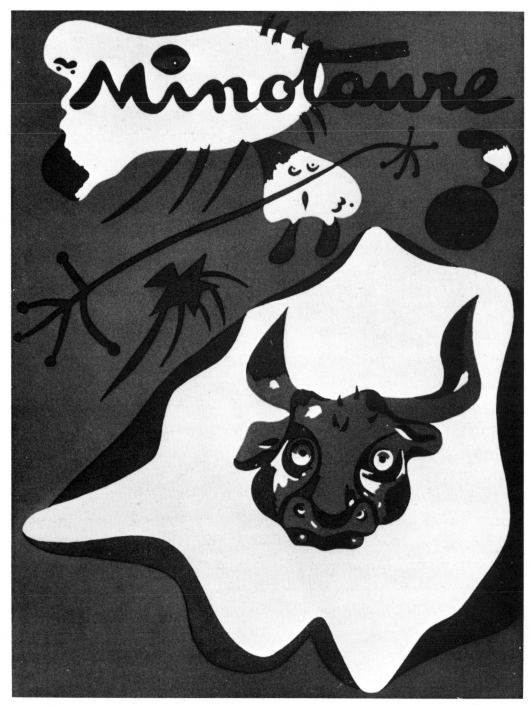

Cover for Minotaure, No. 7, Paris, June 1935.

The heart, the fire, the flight, *this* is what he is after.

So bulls and bullfighting are subjects that you would naturally expect Miró to paint.

After Picasso had designed the cover for the first issue, Miró followed in 1935 with a cover design for the review *Minotaure* and a whole series of smaller drawings for a double page spread. He showed us his 1933 sketches for them, in which horns become a moon and three circles represent the head and the upper and lower parts of the body. Seen together, these small drawings form a sort of Egyptian hieroglyph, a "Constellation."

Unlike Picasso, Miró does not give the bull as prominent a place in his work as it holds in his feelings and fantasies. He talked about *The Bullfight*.

"I painted this picture in 1945, at the end of the war. The French consul in Barcelona managed to take it out of Spain and up to Paris in his car. I gave it as a gift to the Musée National d'Art Moderne. But my choice of picture elements and the almost purely linear treatment of the bull's body, with a very few touches of black, red and green concentrated on the head and one hoof, are all very unlike the preliminary drawings. And I planned out the painting in words rather than drawings; I mean, I wrote down all the impressions I actually get during a bullfight, which you can find in the pages of these 1940 notebooks. I recorded my most vivid impressions in these small drawings jotted down between the paragraphs. All the spectators are pictured there as magic signs, thousands of people as magic signs. They all rise to their feet at once, it's a thrilling sight; a fire catching and spreading and thousands of hands clapping, it's like the beating of doves' wings. I have drawn these flames and these wings. The women open their fans, and the fans are like tiny suns or tiny rainbows: there, that's a fan. The spectators toss up pieces of paper of all colors, it's like a flight of many-colored butterflies: there they are in flight. There's a swallow crossing the sky like an airplane; you see it there. And the spectators are thrilled, because the matador is risking his life, and their hearts beat like one heart: I have drawn that heart. And that heart is also like a female sex organ throbbing with passion and desire; I wanted passion and desire, and so I put the heart in the center of the bullring. The waving handkerchiefs can stand for a phallus—here it is, surrounded by hair. And here are the musical notes for the swallow's cry. And the *banderillas* with their fluttering multicolored ribbons are like dragonflies. It's beautiful, incredibly beautiful.

"Why didn't I keep, why couldn't I keep all that in the painting? Because it wouldn't have had enough pictorial impact. If I hadn't dispensed with these notations as I went along the painting would have been overcrowded and weakened. Of course, I try to bridge the gap between poetic and pictorial: I store up the poetic impressions I have experienced, but they have to cross the frontier, they have to meet the demands of painting. I wrote in these notebooks: *Let my work be like a poem set to music by a painter*. That's it: the painter lives off the poet and the musician, but the painter is the one who can judge because he is the one who *makes*. That's why I never quite agreed with the Surrealists, as they always judged a painting by its poetic or emotional or even anecdotal content. For myself, I've always evaluated the poetic content according to its pictorial possibilities."

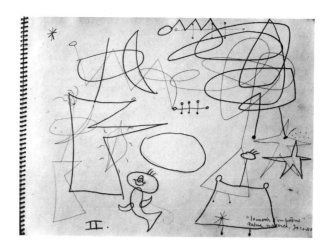

*Preparatory drawing
for In Memory of a Poem.
Palma, 30.10.40.*

This drawing represents the *Matador's Toast*, or rather the *Brindis*; that is, the matador's offering of the bull, preferably to the woman running in his thoughts (and she can be seen here, in the bubble, wearing her Spanish head-dress). Again we find the bird soaring through space, the hands clapping and the fan opening. But here, unlike the 1945 painting, the dead bull is also included.

Sketch for The Matador's Toast.

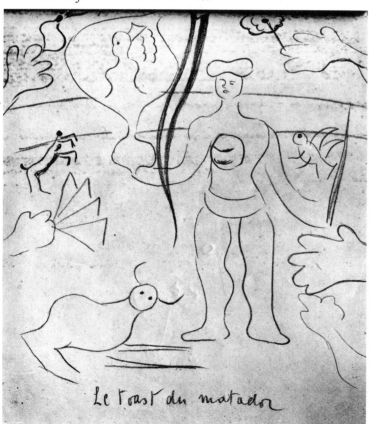

A *poem set to music...* So Miró's impressions of poetry, and of music as well, can also be a source of inspiration from which the pictorial possibilities must be sifted out.

"I remember when I was working on the *Constellations* in Palma in 1940 (they didn't have that title yet, though: in my notebooks I refer to them as gouaches and tempera paintings). In the morning about ten I used to go to the cathedral to listen to the organ. Unlike my Surrealist friends, I've always been very much interested in music, and I can remember Kandinsky telling me that he liked to draw while listening to music: I was struck by that. At that time of morning nobody was around, except the organist practicing, and I used to linger a long while. There was the organ music, occasionally singing, and the sunlight reflected through the stained-glass windows (fabulous, those windows), and the canons with their red vestments in the dim light. (I would have loved to do some stained glass. But I never got the chance.) Later, in 1945, I painted *Dancer Listening to the Organ in a Gothic Cathedral* and *Woman Listening to Music*."

These 1941 drawings anticipate the two paintings, in which vivid blacks, reds and greens recreate the effect of the stained-glass windows and church vestments glowing through the dim light, in a play of circles: those that the dancer is describing in imagination as she follows the

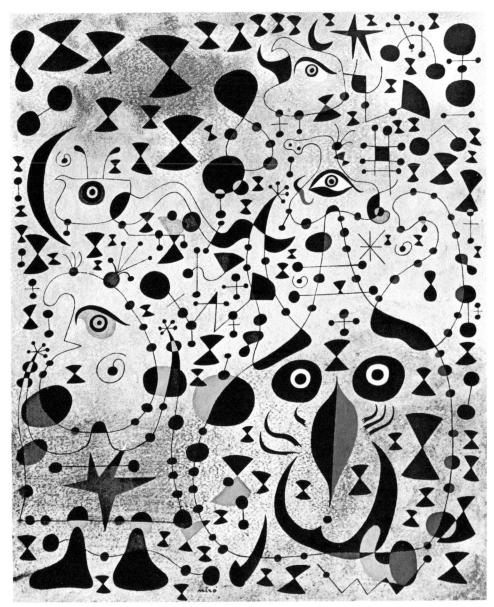

The Beautiful Bird Revealing the Unknown to a Pair of Lovers, 1941. (One of the "Constellations.")

music. But the whole period of the *Constellations* was steeped in music, and Miró was to say that for him the part once played by poetry had now been taken over by music. All these small serried signs and stars are like notes written on the frail and complex stave of lines.

And musical notes mingle with the signs for birds, stars and dancers in this 1940 drawing for *In Memory of a Poem*, in which Miró seems to superimpose two drawings, a thicker, darker line taking over from the initial patterns.

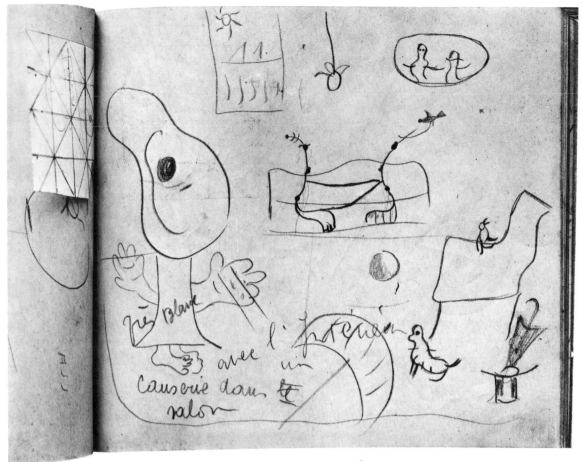

Sketch for Drawing-Room Gossip.

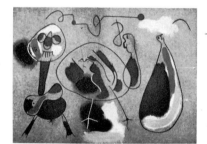

Painting on masonite, 1936.

So only pictorial considerations can dictate whether inspiration derived from another medium and stored up as a written note can survive, fit for use, or not.

The drawing may not work out; it may simply remain an "idea" jotted down. We could understand why *Drawing-Room Gossip* never got painted, when Miró explained it as an anecdote, a synopsis.

"Here are two society women chatting on a sofa. A chandelier. An oval picture on the wall. A window overlooking the sea. And the figure with a big head is the husband; he's really a huge ear listening to what the women are saying. It's rather like Ionesco's *Bald Prima Donna*, isn't it? He has put his umbrella in his top hat. He holds up his arms. He's exasperated by the women's gossip."

Sometimes Miró notes down an intention, draws up a program, but the resulting picture fails to go as far as he had intended. Miró explained the drawing for one of his paintings on masonite, done in the summer of 1936 before he went to France where he lived during the Spanish Civil War.

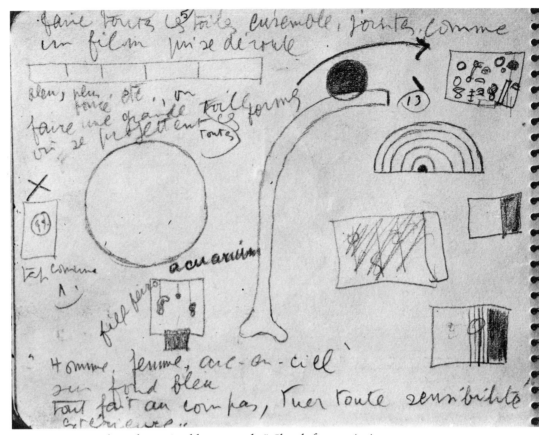

"Man, woman and rainbow on a blue ground..." Sketch for a painting.

Painting on masonite, 1936.

"I did paintings that were far less geometrical than the drawings, because, you understand, when I went on to the picture I worked with enamel paints, sand, substances of some thickness, and the medium conditioned the execution, making me deviate from the original plan. All this arose from *Children's Games*, the ballet for which I designed the curtains, costumes, and above all the 'objects' with which the dancers played. It was a fascinating experience; I was able to go beyond the picture and break up the surface. But I didn't carry out the instructions I'd written down on the drawings. I wanted to splice all the pictures together, like a film unreeling, and project all these shapes on to one canvas. (I sketched out the sequence of juxtaposed paintings and noted down the dominant colors, as you can see here.) I wanted to go beyond the individual picture. I even thought of constructing some wire objects to hang in front of the panels, but I didn't do that either. I also noted on the sketch for *Drawing-Room Gossip* that I wanted to do it all with a compass and kill all external feeling..."

Miró also dreamed of painting a large canvas which would have been his answer to *Guer-*

nica, only without its "theatrical" overtones. He put his vision of it into words in his notebooks: on one side, the *eternal landscape*, represented by a plant growing in the soil alongside tilled fields; on the other, the catastrophic landscape of human history, with a dead child, a howling dog, burning houses and a flying machine invented by an evil genius. But he did not want to do what Picasso did for *Guernica* and develop the painting through a series of preliminary drawings. He wanted to leap straight into the blank canvas, believing that the shock of impact with its white surface would jolt the vision into being. "The fact of starting out from this white surface," he wrote, "will call up images in my mind; these I'll draw as they occur to me..." (So the only drawings done would at once be embodied in the picture, marking out the territory conquered by his leap into the empty canvas.)

He never executed this large canvas. But, working in this very way, by headlong leaps, he did execute the *wild paintings* of winter 1935 and summer 1936: paintings on hard supports, such as masonite and copper, full of contorted volumes and dramatic colors.

"No, there weren't any preliminary drawings for these pictures, except occasionally a vague sketch-plan which proved to be useless. Nor were there any drawings for *The Reaper*, which was exhibited in the Spanish pavilion at the Paris World's Fair in 1937: I threw myself at that surface like a wild man, and it was twenty feet high. I made a few very rough, insignificant sketches, and then I just tackled the canvas head-on, at the risk of falling off the scaffolding and breaking my neck!"

Why was he so intent on immediacy? To understand why, we have to remember what

Miró wrote in 1938 in his article "I dream of a big studio" (in *XXᵉ Siècle*, Paris). He longed, he said, for a really big studio where he would have plenty of room to try his hand at sculpture, pottery, engraving and so on. And he added: "Also to try, so far as possible, to advance beyond easel painting, which in my opinion has a rather paltry message and, by means of painting of another kind, to get into closer contact with the masses, whom I have always had in mind." So, in his eagerness for immediacy, he was not intent on owing nothing to the reality around him, on asserting himself as an omnipotent creator and sole owner of the inspiration arising from his headlong attack on the blank surface of the canvas. On the contrary, he wanted to get outside of himself, to transcend the privileged sensibility of the artist and the individual, to speak a language common to all men. A preparatory drawing necessarily bears the mark of the artist-poet: it is the working out of a private language based on impressions which he is privileged to be receptive to. If, without preliminaries, he shuts his eyes and flings himself at the canvas, then perhaps he will hit on the image that every man will recognize as his own.

A desire to transcend self, a desire generated by the tragic events of the period... But the song of the *Constellations* was to drown out the cry of the wild paintings. Miró remained true to himself. He told James Johnson Sweeney (*Partisan Review*, February 1948): "I felt a deep desire to escape. I closed myself within myself purposefully. The night, music and the stars began to play a major role in suggesting my paintings."

So the eternal landscape wins out over the historical landscape, and a mediator is needed between that landscape and our eye. No doubt

Miró will always cling to the idea of a collective art, magical and mythical, and yearn for such an art. Before leaving him, on the way out through the lower part of the studio, we shall see on the wall some reproductions of primitive Catalan art, of Oceanian, African and Mayan art—not a single example of work by an individual artist. Yet those are the forms that serve as a springboard for him, as do these photos cut out of yesterday's newspaper or an old magazine of forty years ago, these nondescript objects on every side—Easter eggs, Majorcan whistles, toys made of palm leaves, a piece of plywood, some cockled paper, a greenish yellow blotter... So many forms, colors, textures, each one a starting point.

The Catalan Notebooks with their wealth of ideas jotted down, toyed with, worked out or abandoned are closed now, and part of the past. The past? Miró has just glanced at an old drawing and told us that he would like to take up the subject again. The past too is a springboard. There is no such thing as time, only the present moment. And sometimes that moment is brought home to us by someone living and working in it who can only communicate with his fellow men in his own language, a language which he has invented, which we did not know, but which we understand.

"This?"

Nameless forms, unbodied colors: so many gifts lavished upon us, with every gesture he makes, by the nimble hunter of comets, the mighty launcher of suns.

Bullfight

In Memory of a Poem

Large Palma Notebook

Daphnis and Chloe

Palma, Majorca

"A Woman"

Orange Notebook

Diary notes translated from Edmond Raillard's literal French version of the original Catalan, Miró's phrasing and punctuation being adhered to as closely as possible.

I
Bullfight
1940

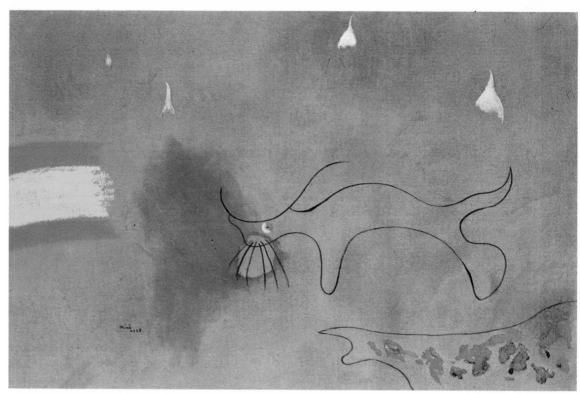

Bullfight, 1925.

look at the enclosure, which will suggest various signs to be treated in a magical way

during the applause after a good *faena*, the audience gets up slowly, and the people look like flickering tongues of flame, and their hands clapping are like the beating of pigeons' wings

fans open, and the opening fans look like small suns or rainbows

a hail of rectangular pieces of multicolored paper heralding some event, unfolding like a flight of birds as they float into the arena

a swallow crossing the sky during the bull-fight

the spectators throb like a single heart; put a big heart on the canvas

the *banderilleros* are like multicolored dragonflies

the horse's blood spurts out in small stars, gleaming like small suns and rainbows

like the blood in a Christian miracle

the waving handkerchiefs could be shown on the canvas as a pulsing phallus

but surrounded with hair

also inscribe in the picture space the graphic pattern of the swallow's shrill cry

put the heart I mentioned in the center of the arena, and attach it to a female sex organ throbbing with passion

all this will give a grander sweep to my idea, and unify my picture without leaving room for any gap and so achieving some continuity in it

Bullfight, 8 October 1945.

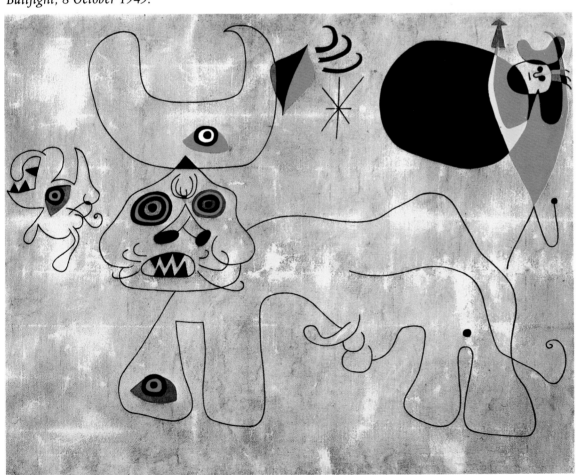

II
In Memory of a Poem
1940-1941

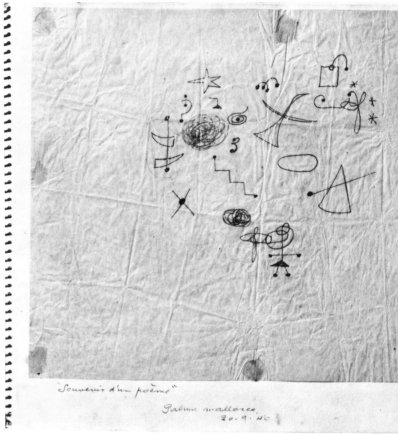

Preparatory drawing for In Memory of a Poem. Palma, 20.9.40.

doing this canvas, keep in mind the book by Lise Hirtz which I illustrated. Look at it again before starting work on the picture

this should be a point of departure toward canvases based on musical forms, works in which the sense of musicality will be increasingly brought out and should in fact precede the actual painting

the canvas will be a very large one, primed with white lead and sand. Over this initial ground spread a coat of white oil paint very delicately shaded with blue, green, pink, yellow, violet, etc. Use very fluid paints, thinned with plenty of turpentine

here and there, around the drawing, add a few dabs of pure color, so the background is like the iridescence of a rainbow

treat the next two canvases in the same way. I remember Benjamin Péret's book *Et les seins mouraient*—look at the drawings and books again before doing these canvases—I can stencil on a few of the numbers, using molds, and do others by hand, so as to get a contrast

think of these canvases as magical decorations on the walls of a poet's house; *a house at the bottom of a lake*

Four illustrations for Lise Hirtz, Il était une petite pie, Paris, 1928.

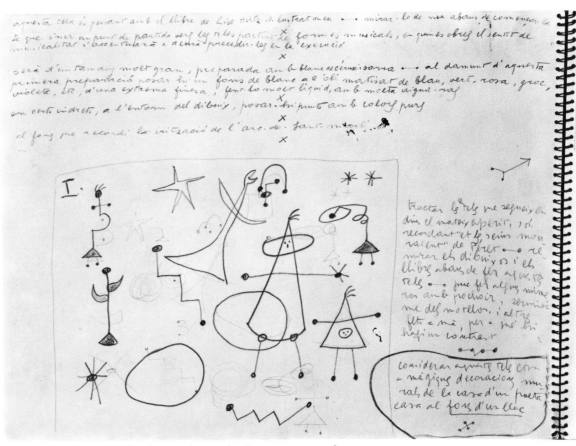

Manuscript page and sketches in the notebook "In Memory of a Poem."

Preparatory drawing for In Memory of a Poem. Palma, 30.10.40.

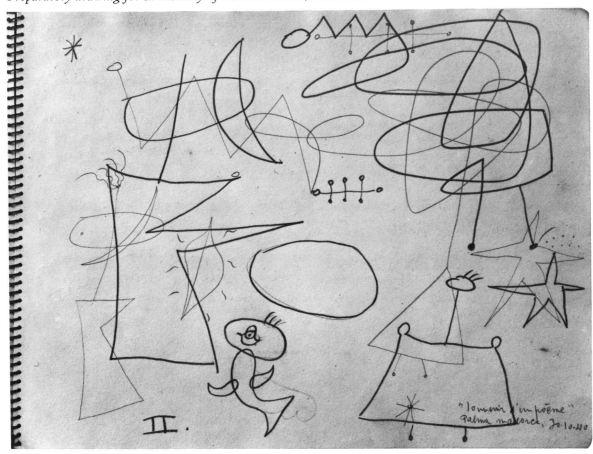

the canvas opposite can be summarized by the later drawing; do a picture with elements of both drawings, starting from one element, this for instance

Montroig, 9 April 1941. I feel that these drawings aren't free enough, as if I were concentrating too hard on how to illustrate the poems. Study these drawings as often as possible and then draw them straight on to the canvas very freely, like the memory of a poem or a piece of music

lots of shapes are repeated too

but straight on to the canvas without the preliminary sketches on paper I mentioned. No, it must be really immediate

be careful to avoid any gratuitous obscenity

these two canvases should measure 330 × 250 centimeters; that is, the size of a 33 × 25 sheet of paper multiplied by ten, which as I expected will give a size 120 canvas enlarged by half

Drawing in the notebook
"In Memory of a Poem."
Montroig, 8/IX/41.

these eleven pictures I did at Palma (eleven drawings) on 19 June 1941 are meant for the series of large canvases based on forms suggested by music. I did these drawings one night while listening to singing in Palma cathedral; there was hardly anyone there, and the light reflected in the stained-glass windows was beautiful. The canons saying their daily prayers accompanied by the sound of the organ

looking at these drawings again in Montroig on 9 September 1941 I feel them to be flat and lifeless. I feel that the title of the pictures, *Escape-Music*, is pretentious, and the shapes are repetitive; when I did them before they had some life in them. So drop this series of canvases, but what I can do, when I come to tackle some big canvases, is to look at the shapes in these drawings to see if there are not some new shapes and make use of them. What I can also do, when I tackle some big canvases, is to keep in mind the magical colors I saw inside Palma cathedral and color the backgrounds in that spirit

Sketch for Figure,
Moon and Star.
Montroig, 9/IX/41.

Sketch for Figure,
Moon and Star.

at another place I've noted down the quality and format of these canvases. Put some Case Arti here and there on the white surfaces, that will enrich the texture; around the linework, against the white, lay in some highly delicate colors, as if drawing with chalk. There is only one white patch on the canvas; against the dark ground of the rest of the canvas, lay in a sign or two in white and perhaps add a figure. Let these canvases be pure magic, something evocative for the mind; let there be no more than linework and signs except for a figure or two on the

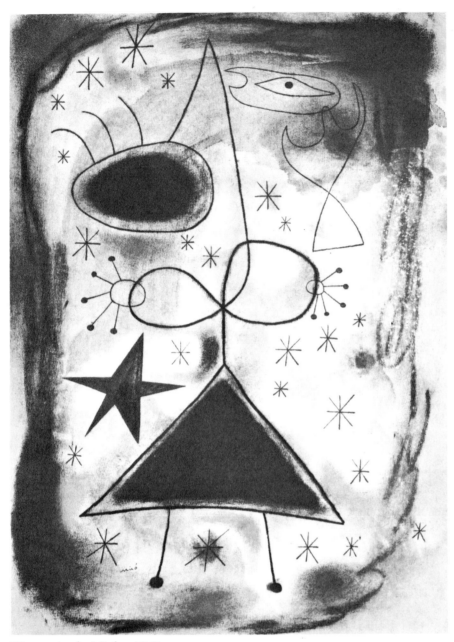

Woman in the Night, 1942.

canvas where there is only one white shape. This reminds me of the stencil I did for New York on the night of 1 September 1941.

The linework of these two canvases can be drawn in quite directly with a stencil brush, as in the canvases prepared in Palma, the canvases of the Montroig Notebook series. The two can-

vases left over in Barcelona from the *Daphnis and Chloe* series of canvases I destroyed: once I get the priming coat off the first with some paint-remover, lay in my linework directly with a stencil brush. And prime the other canvas with some very fluid white: then do my linework on it with Pozzuoli red. Among the club canvases,

on the one where I was to do some color patches, start with linework done in the way I've indicated. Do these two canvases bearing in mind the ones I did about ten years ago in the Rue François-Mouthon, but do them quite directly. Let them also be done with the etching in mind which I made in 1940 for Georges Hugnet's book *L'Usage de la Parole*. Two large canvases of the same type as the one I've mentioned and paint them white. First stage, do the large form in the center with a thick outline and the forms beside it just as if I was cutting out a piece of metal, as in the 1940 etching. Second stage, lay in the outlines of these forms, colored outlines. Third stage, do the linework, let the canvas dry well, then wipe some large brushes or pots of color on it and draw in some new shapes, the ones which in these drawings lie outside the linework, and paint. Around the small shapes of the linework I could put in a very fluid color with a gyratory form, and make the color very transparent by means of glazing. After I've drawn in the bigger and smaller forms with charcoal, it might be a good idea to add the colors that are to surround them and then, when these colors are dry, to draw and paint these forms again. In this way everything will be more alive. Or better still, draw only the large central form and the colors around it and then draw the smaller forms. In that way it'll all be more alive.

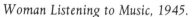

Woman Listening to Music, 1945.

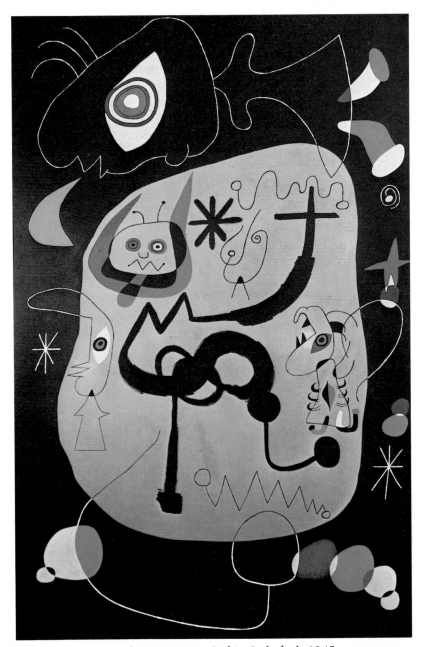

Dancer Listening to the Organ in a Gothic Cathedral, 1945.

I think these broad stripes over the central forms like gaps cut in metal should on the contrary be changed into thin, very sharp lines, as if I had cut into the canvas or slashed it with a pair of scissors. I also think that the subsequent forms, to come after the linework, will have to be done without starting from color patches laid in on the canvas and without wiping the brushes on it, for if they were done in that way they would lack the purity I want. Let this linework be sheer magic and the forms sheer poetry.

III
Large Palma Notebook
1940-1941

The series of drawings done in Palma should be on absorbent Castelucho canvas size 80M, with a sky-blue ground; this priming coat should be applied very unevenly, with strips of cloth, handfuls of straw and the brushes they use in Palma for whitewashing walls. At some points there should be a thicker coat of color; this can be obtained by using the brushes they wash dishes with in Paris. The series of *Women* and *Dancers* must be done on canvases of the same type and size but on the white ground of the canvas. *Figure in Twilight* to be done on the same kind of canvas, white ground, 80P, but fully worked out and modeling the forms in a romantic way, with Modesto Urgell's canvases in mind. For the *Dancers* and *Women*, do the background by applying the brush to the canvas and turning it round in circles.

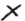 Use stencil brushes. The series of self-portraits to be of the same size as the one I drew in Paris, on the same kind of canvas, covering it with a mixture of dark ochre and Pozzuoli red thinned with plenty of turpentine; in the background, once the thing is painted, fill up certain spaces with very fluid white and go over it again, adding a few colors here and there by scumbling.

The series of canvases on a blue ground can replace the series I planned out at Varengeville but lost. The latter was too much like the series of white-ground canvases I did twelve years ago in Paris.

So as not to waste any time, the "layout" of all this can be done by somebody else.

these canvases can be done after the *Self-Portrait* and the series following it. After that, do the series of large canvases, the *Daphnis and Chloe* series, etc., which will act as a kind of interlude to put me into another mood; and when I get to work, finish the large canvases based on musical forms, etc.

let these canvases be in a highly poetic and musical spirit, done without any apparent effort, like birdsong, the uprise of a new world or the return to a purer world, with nothing dramatic about them and nothing theatrical, full of love and magic, in their conception as unlike Picasso's canvases as possible, for his represent the end and dramatic summing up of an era with all its impurities, contradictions and expedients. Let these canvases of mine be as disinterested as a good poem or the breath of air or the flight of a bird, and just as fine and pure

sharp, sensitive lines, but welling up from the depths, not sentimental as they were twelve years ago. Let them come forth now like a poignant, heartfelt cry

great violence of color

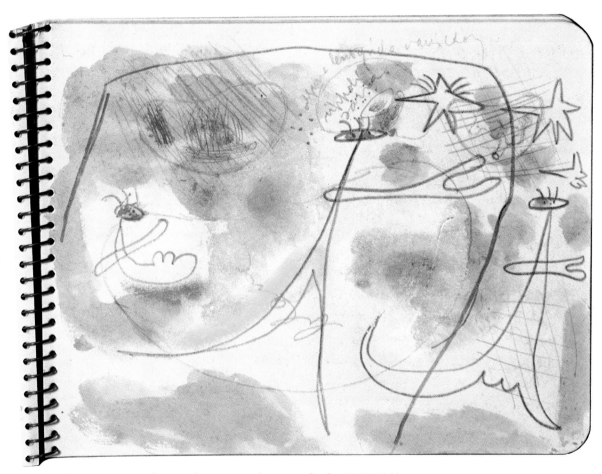

Sketch for Women on the Beach. Large Palma Notebook, 1940-1941.

put the titles in a very general way, without poetic touches, and not as I did in the 1940 gouaches; put for example *Figures and Birds* practically without any change in this title

X

if the Varengeville notebook should happen to turn up again, consult it before beginning these canvases

before having these canvases drawn, think them out carefully, for it may be preferable to do the design myself. If I did, I would get more closely involved with the new dimension of the stretcher and the surface features of the canvas, and most important of all I would get myself

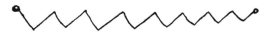

into a certain mood during that interval of time, into a certain state of receptiveness, thus opening the way to fresh possibilities

looked at again in December 1940 these drawings strike me as lacking in spontaneity and sweep

this is due to my being too much in thrall to the strokes that served as the starting point. Prime these canvases as planned, but cover them with a coat of white and before it dries go over it with Prussian blue, mixing it in with a handful of straw, a rag, a dishmop, a Majorcan whitewash brush, my bare hands, etc., until I get

117

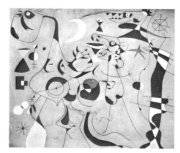

Figures in the Night Guided by the Phosphorescent Tracks of Snails, 1940.

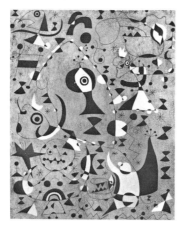

Toward the Rainbow, 1941.

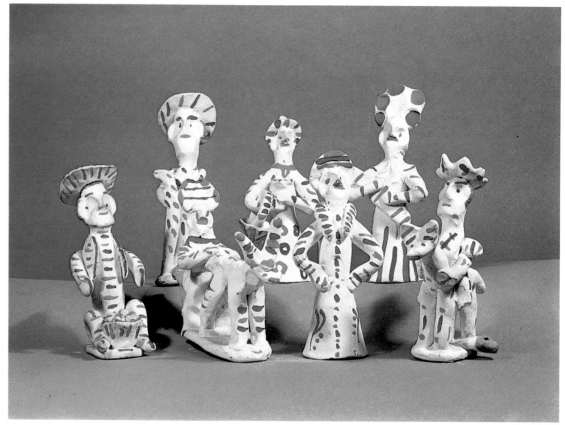

Majorcan xiulets *(painted terracotta whistles).*

the same effect as *sky-blue* chalk. Have these canvases sketched out by another person, and when I get them back use the same procedures as with the 1940 gouaches, only in reverse. Then let them be painted with the greatest possible spontaneity, like Majorcan folk paintings and *xiulets.* Let them be rather like the blue and white 120P canvases, only with more in the way of human elements—faces, eyes, etc. Sheer spontaneity and poetry. There are two many abstract elements, as in Sonia Arp (*sic*); get rid of many and humanize the rest

above all, keep in mind the prehistoric Iberian paintings and those of Las Batuecas which are reproduced in the history of Spain that Alexandre has a copy of

in the series of *Dancers* and *Women* make the ground of a slightly dingy white and add a few areas of brighter color, to get the same effect as chalk or pastel

for the series of thirty canvases use an absorbent canvas, but a very coarse one, with graining and threading

for this next series of canvases, these drawings must be considered as a mere starting point, for they are inordinately vacuous, paltry, unadventurous and realistic. I must start off from them very freely and make the most of them; start off, but brightly and searchingly, from the color patches and irregularities of the primed canvases at Montroig

these drawings are very dreary and unadventurous; they need to be enriched, much enriched. But they must be kept very simple

Cave paintings at La Graja Miranda del Rey (Jaén) and Las Batuecas (León).

refrain from thinking about the shapes of invisible things, as in the series of gouaches and drawings done in Palma, when I come to draw those things and work them up. I mustn't think in terms of preconceived signs, already laid down. I must start off spiritedly from the surface irregularities of the canvas, no matter if the original design proves a poor starting point, away with it and just let the canvas come

all the same I may be able to make something of the poetic signs of 1940, but they must be far more synthesized

when the canvases are done, rework the background with very bright colors applied with the gyratory technique. Use mat white enamel paint mixed with other colors, or else use pastels or chalk

above all don't keep slavishly to these drawings but start off from them as I did in Palma in 1940 from the gouaches I had begun to sketch out at Varengeville

this should be a synthesis of my more sparely designed canvases, and figures and birds should be reduced to signs

as synthesized as possible and carried to an extreme of primitivism, but very expressive and poetic

the utmost spontaneity

the gyratory movement in the background can be obtained first with an oil brush, and, when that is dry, go over it in pastel or chalk with different colors, but very pale ones

let there be no more than intimations of faces, and let these and the signs be informed with a powerful suggestiveness

IV
Daphnis and Chloe
1940

Do a book with reproductions of *my most poetic* canvases together with stencils, prints and my poems going to enhance this book-object

Do a large canvas embodying memories of the wars I have lived through, with the *eternal landscape* on one side, with a plant breeding in the soil and growing beside the plowman's fields. On the other side, by way of contrast, the tragic part, with a dead child, a barking dog, and some houses on fire; in the sky an *invented flying machine* with a fiendish man launching rockets. This canvas should have nothing of the theatrical side of *Guernica*. Only the impact of tragedy (human in its temporal elements, with the eternal side suggested by the landscape which should be very moving and evident).

this canvas should be a very big one; primed with white lead and sand, as Braque does. Gaze for a long time at this white surface so that it suggests images to me, and don't do any preliminary studies, contrary to what Picasso did for *Guernica*. This painting can be done after the *Escape-Music* series. After that, move toward *realism*, landscapes and still lifes

the fact of starting out from this white surface will call up images in my mind; these I'll draw as they occur to me and do studies of them on sheets and on separate canvases in the same way that Picasso did for *Guernica*, only beginning to draw on the final canvas once this initial procedure is completed. This is a procedure quite different from Picasso's, for he started from reality and I will start from the spirit and *white surface* of the canvas

To do this large canvas look over my earlier pictures. See the catalogue of my show at the Pierre Matisse Gallery, 1940. Let all my work be summed up in this canvas. Work on it for years.

For the *Escape-Music* canvases, pin some blank sheets of paper to the wall beforehand, listen to music and note down on these sheets the forms and rhythms suggested by the music, and make use of these forms, signs and rhythms as a starting point.

At the same time as this, do a series of six canvases of the same size as *Escape-Music*, executed and conceived with complete freedom, and great breadth of rhythm, on a blue ground, priming the canvas with white lead and sand as if it were a wall. *Great freedom and breadth of rhythm*.

I think I still have in Barcelona some cans of *artés* white left over after priming the large canvases with a white ground; if so, take some large canvases (which could be withdrawn from the series of white canvases with sand), prime them with Pozzuoli earth pigment, and when they are quite dry lay in some large patches of white (rather in the spirit of the large white canvases I did in the Rue François-Mouthon), laid in very freely as in the case of these white canvases. And if any white paint should be left, prepare a series of canvases with a *very thick* priming coat, giving a tapestry effect, with...

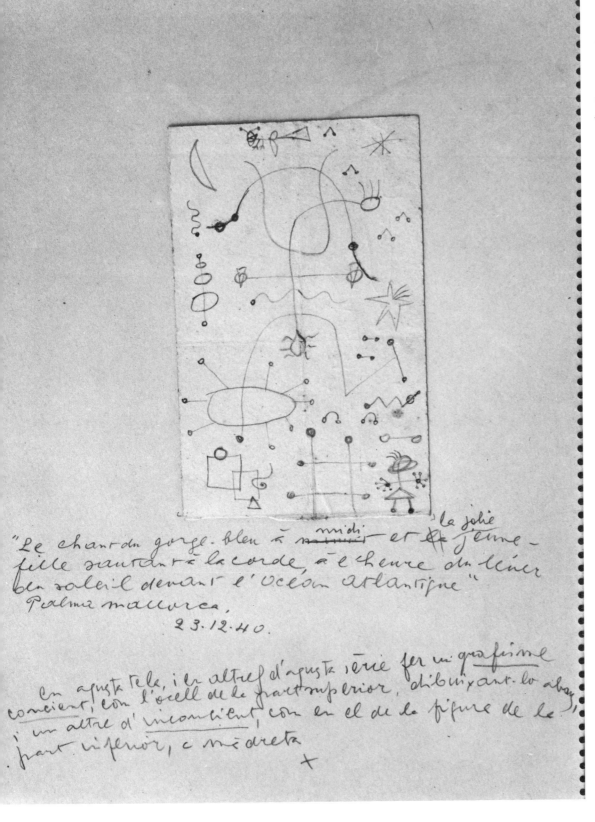

"The song of the blue-throated warbler at midday and the pretty girl skipping rope, as the sun rises over the Atlantic Ocean"
Palma, Majorca, 23.12.40.

on this canvas, and on others in this series, do some *conscious linework* like the bird in the upper part, drawing it out beforehand, and then some *unconscious linework* like the figure pattern on the lower right

"les ailes d'une hirondelle de mer battent de joie devant le charme d'une danseuse à la peau irisée par les caresses de la lune"

Tela 120 F. sobre la mateixa tela i idèntica preparació que la sèrie de pintures blanes projectades el mateix any a Palma

aquesta tela pot considerar-se com la síntesi de vàries recerques de fa molts anys, amb signes poètics i gràfics purs

vist de nou aquest àlbum a Palma, després de 6 mesos d'haver-lo perdut, em sembla absolutament nul — consultar-lo no obstant abans de començar les teles blanes →(el de Varengeville)

això prova la necessitat absoluta de meditar llargament i freda-ment les teles abans d'aventurar-se a realitzar-les

no defugir els fets del destí per contradictoris i enutjosos que de moment puguin semblar, més tard poden coordinar-se amb la recta trajectòria de la vida i de l'obra

considerar aquesta sèrie de tels com a signes esquemàtics i punyents, de pura poesia, vint de l'esperit, com les futures aigua-forts

que aquests signes esquemà-tics tinguin un enorme poder suggestiu, altrament serien cosa abstracta i per tant morta

"The wings of a sea swallow..."
Page from the 1940 Palma notebook.

122

"the wings of a sea swallow beat with joy at the charm of a dancer whose skin is iridescent with the caresses of the moon"

120P canvas on the same kind of canvas and with the same priming as the series of blue paintings planned the same year in Palma

this canvas can be considered as the synthesis of various experiments from a few years back, with poetic signs and pure graphic patterns

I've been looking through this notebook again in Palma (the Varengeville notebook); after losing sight of it for six months, it strikes me as utterly worthless—consult it however before starting work on the blue canvases

this shows how necessary it is to think coolly and at length about the canvases before venturing on them

don't try to dodge the facts thrown up by fate, no matter how contradictory and troublesome they may seem at the time, for later they may fall into line with the unswerving trajectory of my life and work

consider this series of canvases as so many poignant schematic signs, sheer poetry, a cry of the spirit like my future etchings

let these schematic signs have a tremendous suggestive power, otherwise they would be something *abstract*, therefore lifeless

nine months later—it would be a funny coincidence if this took the same length of time to do as the *Farm*, which was the summing up of one part of my work, but also the starting point for a part of my work that I was to do afterwards. In Palma I'm doing some other drawings by *setting in order* the ones in this notebook which I drew at Varengeville and which tie up with my blue-ground period, but are purer and more forceful. When I first looked at them here in Palma they seemed to me useless, a mere repetition of something else, but looking at them again and doing these new drawings, I think that when they are carried out they will have great value as showing the infancy of a form of expression which in the fullness of time will arise from the catastrophe and ruins of the present day.

✗

they can be done with 120P canvases on a canvas already primed with a very thick and solid white. Add another coat with sand in it, as Braque does, leave it for a year, then add another coat of white and over that immediately afterwards, with a handful of straw, a rag, my hand or a Majorcan brush, apply a little Prussian blue which, mixed into the white, gives a color resembling a very pale sky-blue (though in places dark and stormy), as if it were done with chalk; but only in some places, leaving some patches of canvas in pure white. Let this be done in an irregular, very spirited way

the lines that I shall draw in over it should be very sharp, the poignant outcries of the soul, the whimperings of a new-born world and a new-born humanity arising out of the ruins and rottenness of today

in some places use a thick round brush, to do the outlines, and in others on the contrary extremely fine, pointed brushes. Keep in mind how very important texture and technique are

✗

80P canvases over absorbent Castelucho canvas primed as in tempera painting, unevenly, with *sky blue*. Use a handful of straw to prime them, so that the blue surface is not opaque, but very transparent, letting the almost white canvas show through here and there

✗

don't keep slavishly to these Varengeville drawings, just use them to start from, to retrieve the mood that inspired them, but *working them up* and making them pictorial, but *retaining* that linework, a pure expression of spirit

✗

The initial drawings are poor and done with too much reference to some of my earlier works.

✗

To enrich them and make them more authentic, begin by drawing the last ones, in that way the first will benefit from the last and they will balance out.

✗

In the final priming, when it comes to putting on the coat of white that is to be mixed with the Prussian blue, put on the white only in the places where the blue will need to be put, but let the white extend a bit beyond, and that will give me a greater richness of texture.

Palma, Majorca, 18 January 1940

VI
"A Woman"
1940-1941

the sexual symbolism of these canvases is rather unnecessary

 ✕

enrich them with some of the poetic elements of 1940
let the *humor* of them be very obvious

 ✕

very strong and powerful canvases
have these canvases sketched out by someone else by a mechanical method, so that I don't waste my time

 ✕

once they are outlined, and after letting them stand for a good while, draw over them myself, but very freely, simplifying the forms and enriching them poetically

 ✕

in these canvases some elements are too realistic; on the other hand, some elements, which need to be brought out with realistic vigor, are lacking in it

 ✕

humanize them more

 ✕

more pictorial while at the same time less abstract

 ✕

some elements, however, like the leaves in *Daphnis* and the *Storm*, must be rendered in minute detail, with the veining of the leaves and all, like the pot of flowers I painted in egg tempera years ago

 ✕

create new human beings, breathe life into them and create a world for them

 ✕

don't worry about when these works will be carried out, give no thought to the passing years and time, just let them work themselves out in my head

 ✕

a grandeur recalling the Easter Island sculptures

 ✕

shun the idea of Arp's "Concretions"

 ✕

keep in mind the thought of sculpture, so that these forms turn round and can be felt

 ✕

before starting to sketch them out definitively, read the text again

 ✕

in their present state these works can serve only as starting points, and when I come to execute them they will need to be enriched with later insights

 ✕

the question of dating is purely anecdotal, what matters is the sum total of my life's work; when I can do no more to it, it will be a soul laid bare

 ✕

it's pointless worrying about whether or not I can finish all I have to do in the space of my lifetime, that would be a failing; what matters is not to finish a work, but to let it be seen that some day it could lead to something

 ✕

look to the future with complete confidence, it doesn't matter if I die before I can make my work known

let there be a great outburst of color

one must be prepared to work on in the face of the utmost indifference and in the greatest obscurity

let the forms and proportions take on a biblical grandeur, more deeply imposing than Michelangelo

live to work as long as that is possible, and when the means to keep on working are no longer there, withdraw even further into the palace of the mind in purest contemplation

before outlining these canvases in their final form, look very closely at the preparatory drawings in this notebook

if the supply of working materials runs out, go down to the beach and make lines in the sand with a bamboo stick, draw on the dry ground with a stream of piss, draw in the empty air the pattern of birdsong, the sound of water and wind and cartwheels and the humming of insects, and let the wind and water sweep it all away afterwards, but act from the conviction that all these pure devisings of my mind will magically and miraculously find an echo in the minds of other men

also look at the large sheet of paper I kept on my table in Palma through the summer of 1940, on which I did drawings with these canvases in mind; these scattered elements will be of great use to me in carrying out all these works

think in some way about the potentiality and severity of Romanesque paintings

do not despise the offshoots of my work, the scraps of paper and cardboard I've picked up, the rags I wipe my brushes on, etc., these are all things that God has put in my path and that I can use to enrich my work

at other times think of the fantasmagoria and romanticism of Modesto Urgell

intensity, yes, but also a great severity in the colors

what counts is not one's work, but the trajectory of the mind over the whole of one's life, not what a man has done in the course of his life but what it gives an inkling of, and what it will enable others to do at some more or less distant time to come

for the canvases still to be done in this series, take a primed canvas, already gray or white; if it is white go over it myself with a thin coat of gray, the gray I have in Barcelona, and once it has been sketched out by another person, fix it and cover it with plaster, but letting the initial drawing show through a bit, and draw over it myself very freely, that will be very convenient for me to draw on, and when I do the painting I shall obtain a fresco-like texture

let the works be conceived in a frenzy, but carried out with a clinical coolness

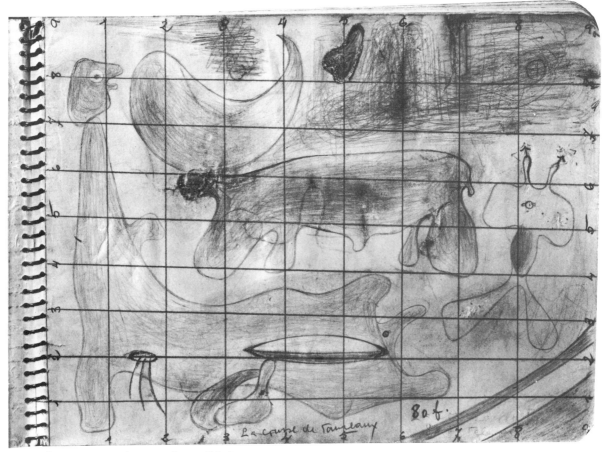

Squared preparatory drawing for Bullfight.

Preparatory drawing for The Family.

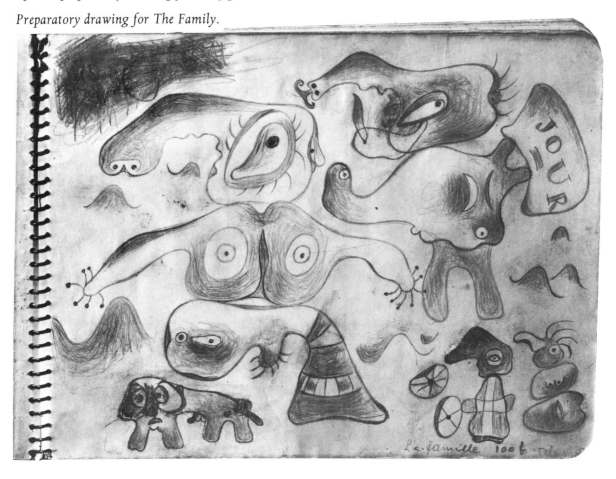

work with the utmost self-possession, as if nothing were happening in the world, it's all being worked out already in my unconscious mind

✗

before beginning the *Storm* read *La Religion du Tourne-Sol* in Saint-Pol Roux's *Reposoirs de la Procession*

✗

work very slowly with the dignified composure of an old craftsman, that's the only way I will obtain a beauty and firmness of texture, think of the case of Picasso, when you see some works of his after a few years' time they fail completely and look weak and empty

✗

keep up a steady discipline in your work, but at the same time spend hours and hours in meditation and contemplation, the food of the spirit

✗

but see that that discipline is in no way transformed into something mechanical, let it be above all else something human, and in given circumstances break off that discipline

✗

working method: pass absolutely unnoticed in Palma and work there with discipline; in Paris spend the morning preparing my graphic work, lithographs, monotypes, etc., and spend the afternoon seeing museums, exhibitions, etc.; devote the months I spend at Montroig to doing sculpture

✗

so organize my life as to be independent of painting, as true poets do, and never let myself go so far as to become a businessman; when business has to be done, be very exacting, as befits an artist's pride and because that is the

only way to make oneself respected by the bourgeois—think of likening oneself to that sort of individual—if it fails to work out, decline the whole business, and if business must be done, let it be done in style

✗

must go into the matter of the farmhouse seriously, it would afford me an independent livelihood and, what's more, this direct contact with the soil and the men who till it and the elements involved in it would be of great human value to me, they would enrich me as a man and as an artist

✗

technique has its importance and opens up innumerable possibilities, think of Klee and L. da Vinci

✗

in *Daphnis and Chloe* there are some unnecessary influences stemming from Arp which must be eliminated

✗

some stemming from Dali too which must go

✗

have these canvases sketched out by another person by mechanical means, let them stand for a long while, and then having fixed them lay in a coat of plaster over that and draw them with great freedom, making good use of the things I've done since this notebook, and let all that be imbued with grandeur, it doesn't matter if the outcome is very different from the drawings I used as a starting point

✗

for the *Spanish Dancer* bear in mind the monsters I did in 1940, the dancer I've sketched out keeps too close to reality, make it more like a fetish

✗

for the *Bullfight* seek out some poetic symbols: let the *banderillero* be like an insect, the handkerchiefs like pigeons' wings, the horse's wounds like huge eyes; also make use of signs like the ones I devised in 1940 instead of over-realistic elements in the interpretation of the flag over the enclosure, for instance

✗

same goes for the blood spurting out like an ideogram ending in a star-shape

let these canvases be full of humor and full of poetry, like Jarry's writings

✗

do these pictures on very thick white canvas, already primed, go over it with a very light coat of gray, and then draw

do this series at one go with the utmost vehemence and the utmost intensity

the drawing of these canvases must be more exaggeratedly poignant, more synthetic and more emotive and more violently harsh

in the *Family* the humor and poetry should be carried to a higher pitch—the pipe should stick out of the father's eye, and the newspaper he's reading should be full of ideograms, of poetic and astronomical signs

in the same picture the dog must be very fierce

the bull in the *Bullfight* is too abstract, its head must be terrifying, like the dog in the *Family*

✗

the *Spanish Dancer* must be cruelly comic, with some nails hammered in—the floor can be covered with poetic and astronomical signs, based on the graining of the wood

in *Daphnis and Chloe* the bird shapes should be suggested by the clouds, rather in the spirit of the *Grasshopper*—it should also be reminiscent of *Paul et Virginie*

After the Crime should be full of cabalistic signs

in the figure and background of the *Spanish Dancer* there should be some of my 1940 signs

think about the metamorphoses of the Second (?) Faust for *Daphnis and Chloe*

bear those metamorphoses in mind for this whole series of canvases in general

for *A Woman* think of the prehistoric idols reproduced in the first volume of the history of Spain owned by Alexandre

when I have had these canvases sketched out, before beginning one of them keep it in front of me for a long time and start doing drawings and preparatory studies in a separate notebook, before carrying out the final version

before doing the *Family* I should look at some photos of the large drawing I did a couple of years ago, as a point of departure between the latter drawing and the one in my notebook

make the dog in the *Family* very fierce and the rest very rococo

The canvases begun in Barcelona are badly primed; as I won't be undertaking this series for a few years anyway, rub them out and I'll indicate later what I should do with them; have them sketched out at the earliest opportunity on half-grained canvases, already primed when I buy it and having a rock-like quality, but not too rough; if it's white, go over it with a coat of very fluid red ochre, and after having the design laid in by a draftsman, cover this initial state with white tempera and then with plaster before drawing on it myself; before beginning them myself, keep looking at them for a few years, once the first state is sketched out; this series, which must be fully worked out and modeled like sculpture, should serve as a halfway stage to bring me on to the large canvas, which can be planned and begun while I'm working on this one; there should be elements in it of a certain realism, taking great care not to lapse into the ideograms and signs of 1941—let these canvases have the sobriety and dignity of a large fresco— before painting this series of canvases, look at the works of L. da Vinci and Millet, which are full of sexual symbols

before drawing in the *Spanish Dancer* look at the drawings and sketches I have in Barcelona for Mère Ubu

have this series of canvases sketched out in red chalk or sepia, so it won't be necessary to fix them, and running my hand over them afterwards and then adding a coat of plaster I shall get a very fine texture

Preparatory drawing for Bullfight.

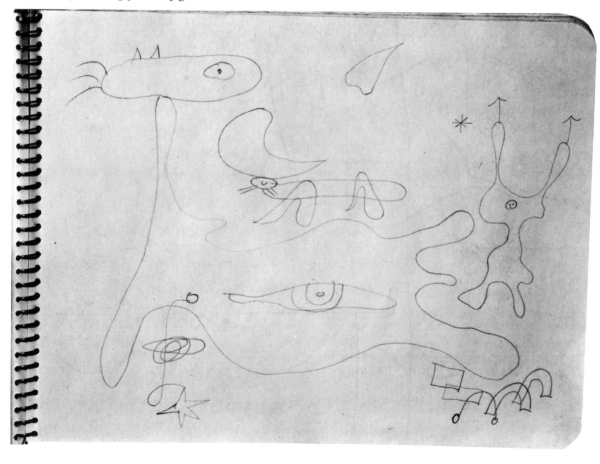

130

Palma, Majorca, 15 January 1941

Use a coarse-grained canvas, but make it smoother with pumice, so that for all its coarseness it gives the impression of being fine-grained —go over it with a very fluid coat of gray (and not red as I had planned)

it would be very wise not to execute these canvases, nor the ones in this series of *Women* sparked off by a hallucination, until much later; in that way, cool and collected, one can launch into the venture quite safely, with self-confidence

✕

"A Woman"

Palma, Majorca, 30 December 1940

80F canvas using the same kind of canvas as for my self-portrait, but going over it with a second coat of red ochre—then paint the figure with great simplicity, do the outlines in black, give it a white background thinned with plenty of turpentine, leave the volume of the figure in the background of the canvas, putting in a forceful blue somewhere

do what is marked with a cross on the previous page; do it vertically like the others

"A woman." Sketch and manuscript page in the notebook "A Woman," Palma, 30.12.40.

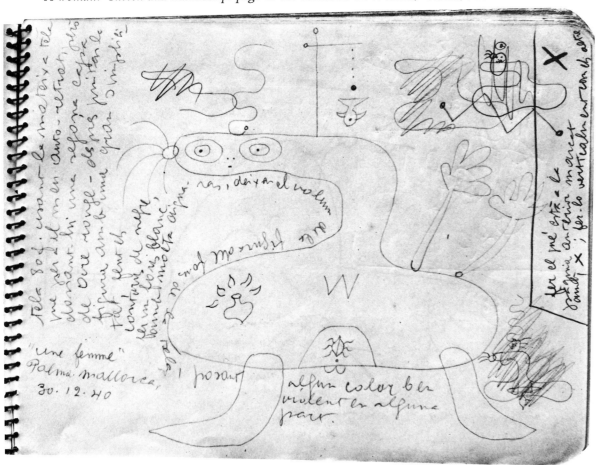

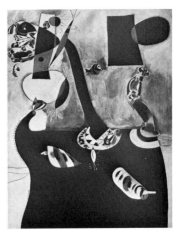

Seated Woman I, 1938.

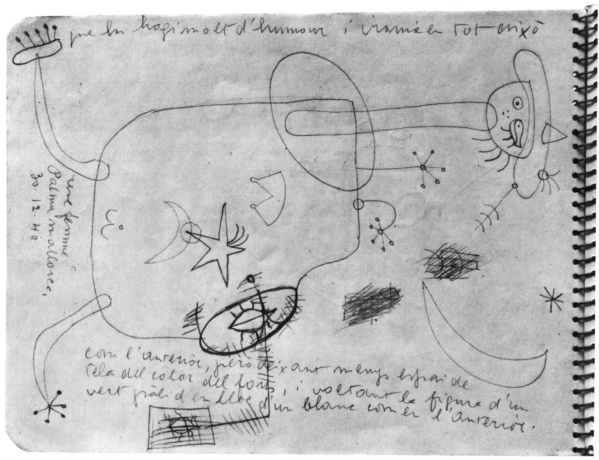

"A woman." Sketch and manuscript page in the notebook "A Woman," Palma, 30.12.40.

Palma, Majorca, 16 January 1941

The faces can be painted entirely in black, doing the outline of the nose, mouth and eyes in white

the lines must be extremely sharp, as in the canvases with a blue ground which I did twelve years ago

this series of canvases can be a continuation of *Woman I* which I did in Paris around 1938

Palma, Majorca, 15 January 1941

I'm now finishing the series of *Women*; it is possible that if I look at them again after a while, *some* of them may seem to me childish; set no store by that impression, look at them again still later and they will certainly strike me as having great value as a *spiritual* starting point, the quite logical outcome of my current experiments—it would seem, all the evidence is there, that I am now trying to give a more *solid* foundation to my previous work which looks to me today like no more than a rough draft

VII
Orange Notebook
1940-1941

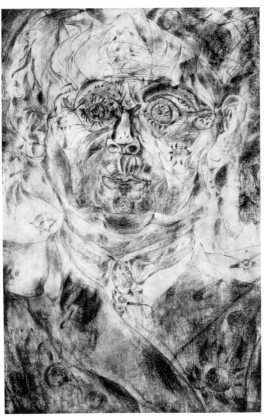

Self-Portrait I, 1937-1938.

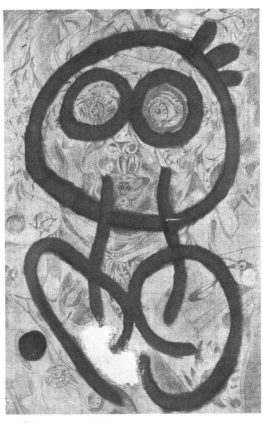

Self-Portrait, 1960.

Work slowly, like a goldsmith, so that when I set my works aside and take them up again they acquire a patina, like old gold or a buried emerald—let everything have a great richness of texture, think of Becquer's poetry, how the words are highly wrought and precious, he seeks them out as if he were stringing a necklace with precious stones, and by working slowly in this way the images will take shape little by little in my mind, clothing themselves with finery and precious stones, beware of the quickness with which all pseudo-genius works

For the big self-portrait pass a damp sponge over Freiss's design so as to rub out his drawing a bit, next go over it with sandpaper, then with a coat of white gouache, and finally put in some plaster over it, in this way I shall obtain a fine texture on the canvas—then draw on it, adding in the background some of the signs of 1940-1941, that will give it greater mystery and establish a parallel in my work

I can for example add the Catalan cap that I had planned to wear in the self-portrait I did about twenty years ago, and put in some signs from the 80F canvases of the *Catalan Peasant* that I did in Paris a few years ago, but drawn more schematically, as in 1940-1941

and so one would get a landscape-portrait, such as I had planned and expected

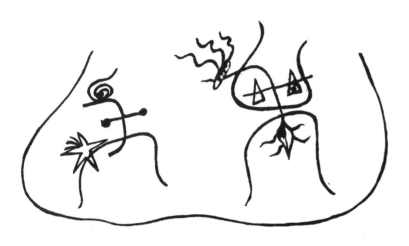

if by any chance I wasn't interested in painting a Montroig landscape, as I had vaguely planned to do when I was in Paris, I could intersperse some poetic elements of that landscape in the figure in this self-portrait, as I had some idea of doing in small egg tempera paintings, for example the ear ending in a carob tree, the hair of the beard forming a vine, the coat tails turning into the pointed Escolnalbon mountains, the hair into olive trees

when the strips of canvas left over happen to be long and narrow, hang up some of them on a piece of cardboard, leaving the frayed edges as they are, cover them in places with Case Arti and go to work on them, as if they were different friezes

for the series of 24 small canvases that I left in Paris, moisten them and draw on them with a glazier's point in Indian ink so that the line is very sharp, and over it apply some watercolors and then pastel, gouache and oils—others can be moistened directly with watercolors, then follow the same procedure—for others, I can fix the drawing and then with oil colors dot the line that should be done in charcoal, then go to work on it—for others, follow the same procedure, but first rub the charcoal drawing with pumice so that it is half obliterated—for others, I can draw the lines with a Japanese brush and Indian ink, fill in the background, leaving a blank space of unpainted canvas to separate the lines, and put in some watercolor and some faintly tinted mat white enamel paint—which means that the canvases of this series must be as delicate as a butterfly's wing and fresh as bird-song

△ next do one or more canvases, but very simple ones, following the same procedure as for the self-portrait

134

primed with white lead and sand, as Braque does, and over that a very liquid coat of sky blue applied unevenly—do only three canvases—use no concrete forms, bring linework and ideograms into them, including at most one or two objects of poetic representation, a bird or star—let these canvases be based on the tempera paintings I did in 1940, but greatly simplified, so that they look like the wall paintings in some otherworldly palace—also bear in mind the series of automatic etchings that I have planned

prime this canvas with white lead and sand, as Braque does

procedure for creating this work: remain in contemplation before this white canvas and do various drawings on sheets of paper.

Do a large escapist canvas (like Pablo's) but in a very different spirit, a breakaway toward the eternal side of life. Use the wounded child that I already have, on one side—in the background burning houses half consumed—in the foreground a panic-stricken peasant, like the one I have already done—on the ruins of the house a rooster like the one I have—up in the sky a plane done like a bird of fantastic shape in the spirit of Bruegel or Hieronymus Bosch—a barking dog

on the other side of the canvas a man plowing his field with a mule or an ox; the eternal side of things, a plant sprouting in the ground and growing—birds playing musical instruments in the branches of the trees, think of Marc Chagall—the furrows of the plowed field— a blue sky—monster men coming out of the fantastic bird and shooting rockets.

in the woodcut I see very great possibilities, but only if it is done in a *present-day manner*, unlike those who wish to revive (!) this technique and practice it just as it was practiced five centuries ago, without realizing that it was once done like that because there was as yet no engraving *with the burin*; the gashes they make have no justification any more, now that we have this newer method invented much later; they are merely keeping up a spurious, unnecessarily folksy tradition, they have become a slave to their technique, like Ricart and Galanis. Now someone who has really understood the woodcut is Arp in his illustrations for Tristan Tzara's *Vingt-cinq poèmes*. Start from the piece of wood and for line magic cut into it forcefully, with the black-line method—pour ink over the wood, and work up the design from these ink spots; work it up too from the blobs of wax that I'll drop over it and from the shapes of red-hot tin that I'll lay over the wood—Print a very limited number of woodcuts and color all the impressions differently, in the spirit of the *images d'Epinal*—Draw over them to see what comes of it. As line engraving gives lifeless results and the burin here opens up far more possibilities, do

135

some large black patches with very forceful outlines—the highly *contrived* technique of negative prints: also color some of them with pastels.

starting to do some sculptures at Montroig, I have regained contact with the earth, and that will give me, in the deeper sense of the word, a more human and direct awareness of things— sculpture done in the country in these circumstances will not be tainted with superficiality or artifice, as it might well be in town, deprived of direct elements, with the danger of its being the work of a sculptor who cannot get beyond that one art form, like a specialist in engraving who cannot get beyond engraving.

do not be overmastered by accidents, master them

scatter some patches of color over black masonite: when dry, apply a coat of very fluid mat white enamel and work on that.

Work on the wooden objects sketched out in a notebook that's in Barcelona—do the designs and models and have them executed by specialized craftsmen; I'll finish them afterwards—do not make them as abstract as in the sketches, humanize them more.

think of the small objects made in Majorca for the Christ child's crib, and the clay pipes they sell on St. Anthony's feast day

Color my terracottas as they do the small crib figures

Pottery
Dishes—Pots—not for the sake of art, but for the sake of making objects fit for use— Tiles—Jugs—Majorcan pots.

Folk-art technique, putting on the color drop by drop as it trickles from a burette, as for the dishes.—See some of the folk objects made in Majorca and decorate them, for example the pots that are hung up in farmyards for the chickens to drink from.

Jugs that the fishermen take with them in their boats.

✗

Pokerwork
Burn in the designs on wood and bone.

Decorating glass
Porrons and Catalan glassware.

take some wooden boards as they come from the shop and make the most of the empty space between the veins, engrave straight on to the wood, against the grain

use the instruments that are employed to engrave in linoleum in quite a subordinate way, use nails, and look around for some instruments that would give the engraving the effect of graffiti.

try and make something out of the designs in relief on the linoleums they sell in shops.

think of the drawings I did in 1940 for Lise Hirtz's book; follow the same procedure in the stones for the drawing and coloring.

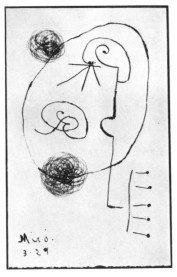

Lithograph of 1929 for Tristan Tzara's poem "L'Aube des voyageurs," 1930.

also think about the drawing I did in Tzara's book—begin by drawing the stone in black and after that apply the colors—do this at the printer's so that the work is more direct, do it while waiting for some more stones, wipe the brushes on the new stones, as in my tempera paintings of 1940, and go on with the work from there.

Woodcuts
color some of the prints by hand.
Enamels
Monotypes
Linocuts
Lithography
Use plenty of *transfer paper* and obtain different textures—Trace on the paper various kitchen utensils and all sorts of others, starting from that—cut out shapes from sandpaper and trace them off.

Color lithography (do a series of them with a Japanese brush and colors in the spirit of the colored drawings that I've put in the books I've illustrated)

On the other paper. Do some drawings automatically with lithographic ink and a Japanese brush—obtain some wash drawings like those of the Japanese, whom I must keep constantly in mind—print hands and feet on them—print stenciled letters on them—Drop on them at random a piece of fine string dipped in ink—Spatter ink at random so as to get some spots—draw with the trickle from a burette, from a sprinkler—print some very ordinary designs with a stencil like the ones used for painting walls or for decoration—make up these shapes to be printed myself, from adhesive wrapping paper, cutting them out with a cobbler's knife—take a piece of newspaper, moisten it with lithographic ink and print it on the paper—press it down with a squeezer or else some kind of fastening device—make use of a cuttlebone to get shading—make marks with a goosequill or any other writing implement—burn a piece of paper and start from the shapes left by the fire.
make a point of always collaborating with the printer, work in accordance with the old traditional procedures of each country, old printing houses in Barcelona and Palma with traditions that are unknown in Paris.

think of the masonite panels I began in 1940, starting out from graffiti.

think of the series of large canvases

137

in lithography and engraving remember that the only thing to do is to master the accident, and *in no way* be mastered by it; the work will thereby be all the more forceful, and so will the offshoots from it

— in view of the latest, purely poetic trend of my current work, there is no point in either publishing or illustrating my poems, since it's all in my painting.

— use the same color, but different brands of it, as they vary a lot.

— for applying colors and adding things over them, don't use panels, but take more or less large pieces of masonite (of all sizes) and put them on trestles, cover with Case Arti; that, along with the accidents that may occur, will give me a further working element, which will have to be followed up, just as in life one has to follow up one's *Fate*.

Engraving
You can engrave on celluloid
Take the lids of biscuit tins and engrave on that, making the most of accidents, working in drypoint

✗

Baudelaire said that engraving was the pure handwriting of the mind.

Prepare 20 or 30 plates, and when the ground is ready engrave them with a needle or a phonograph needle, doing an automatic design without any conscious control, pull some prints of this first state and work them up by various techniques.

Once the plate is engraved, sprinkle a few grains of sand over it and run it through the press so that they too remain engraved on it.

After the engraving add a gyratory movement in drypoint.

When the engraving is done treat the ground with aquatint.

Use these three techniques simultaneously and also make a few holes with a point.

For this series of engravings keep in mind the tempera paintings I did in 1940 and above all the series of oils

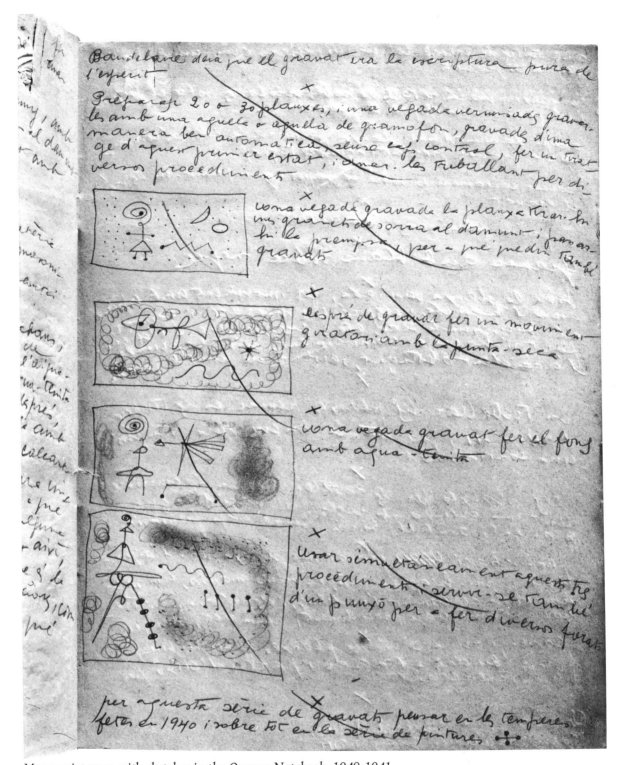

Manuscript page with sketches in the Orange Notebook, 1940-1941.

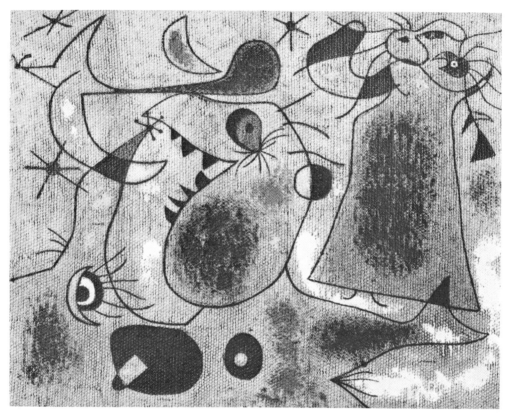

Figures and Birds in the Night, 1939.

Start out from the texture after eliciting a textural effect beforehand, as in the last stage of the 1940 tempera paintings; on an etching plate, for example, with a prepared ground, lay in some touches of aquatint here and there, then rub it with charcoal, and immediately after make a few holes and scorings with the burin and drypoint; put some sandpaper at one end and some printed grains of sand at the other, spit on the plate so that a form is suggested by the shape of the spittle, start engraving and go on like that in a very spirited way, remembering that the resulting figurations are inspired by the texture of the ground, just as in Hölderlin the idea was inspired by the *word*.

JOAN MIRÓ

*De l'assassinat
de la peinture
à la céramique*

De l'Assassinat de la Peinture à la Céramique ('From the Murder of Painting to Ceramics') is an unpublished text written by Miró in 1944 when he was working with Artigas on his first ceramics. The manuscript belongs to the Fondation Zervos at Vézelay; the artist meant to use it as the basis for a book, but he abandoned the idea. We should like to thank Jacques Dupin for giving us access to it.

DE L'ASSASSINAT
DE LA PEINTURE

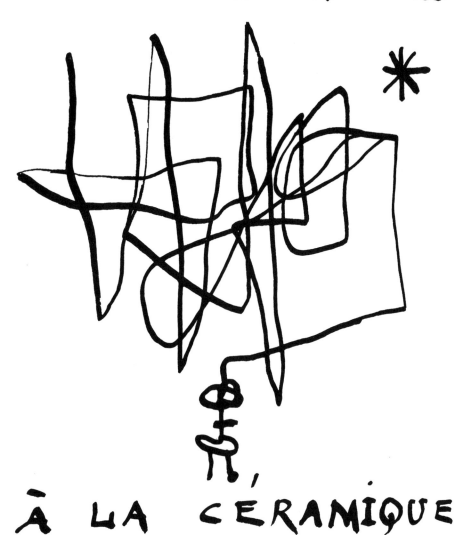

À LA CÉRAMIQUE

des céramiques qu'on peut se jeter sur
la figure pendant les extases d'

non pas ces vitrines
à la couleur des nichons des
la Seine

avec des plats qui ne sont même-
pas signés !

même-pas signés, voyons, que vont-ils dire
ces gros parapluies à la figure de
grenouille qui pètent des bulles de
banque aux gros orteils parsemés
de taaaaaaaaaaaaaaaaaaaaaableaux
peints à la couleur à l'huile de
figue sèche sur châssis de ventre de
baleine, ça vaudra pluscher, cher
monsieur

pour picoter l'
arc-en-ciel

de ceux qui disent que

2 et 2

ce qu'il faut c'est que 2 et 2

fassent

des istes aussi artichauts à trois cheveux
de radis que les ismes

Soeur hirondelle jete des
diamants sur la terre glaise l'aile de l'
hirondelle **dessine** des graphitis sur ces
céramiques sillonnées par la chevelure de
la petite ouvrière

— cinq sous la pièce une étoile
à se mire

font 4.

merdre,

le vieux général aux fesses
épinglées sur les oreilles en forme
d'ailerons commande aux thypes
tulipes marchez à droite marchez
à gauche visez à droite visez à gauche

que le bout de vos œillets pisse

des rossignols

dans lesquelles les amoureux mangent des
cressons avant ces

Extases

figées des porcelaines
danseuses décadentes dansant sur
par un jour de brouillard

les assiettes qu'on vend cinq sous la pièce

faits avec de l'argile qui fait pousser
des champignons et des échelles en
tournesol

comme la

céramique de
PICASSO

LIST OF ILLUSTRATIONS

Self-Portrait, 1919. Oil on canvas. (30 × 23 ⅝") Louvre, Paris. Picasso Donation *frontispiece*

Painting on torn cardboard, 1975 9

"Woman, bird." Drawing, 13 April 1957-24 February 1975 10

"Woman, bird." Drawing, 22 February 1975 11

"Woman in the night." Drawing, 24 February 1975 . 11

"Man pissing by starlight and bird." Drawing, 24 February 1975 11

"Person catching a bird." Drawing, 24 February 1975 11

Painting on paper, 1975 12

"Le Monde." Painting on newspaper, 18 March 1970 . 13

Two paintings on paper, 1975 13

Four paintings on paper, 1975 14

"Cornudella." Drawing, page 34 of the 1905-1906 notebook 15

"Cornudella." Drawing, page 11 of the 1905-1906 notebook 16

"Palma de M." Drawing, page 40 of the 1905-1906 notebook 16

"Sineu (Palma)." Drawing, page 35 of the 1905-1906 notebook 17

Nude figure on all fours. Drawing, 1915-1919 notebook 18

Nude study. Drawing, 1915-1919 notebook 19

Two nude studies. Drawings, 1915-1919 notebook . . 20

Three nude studies. Drawings, 1915-1919 notebook . 21

Sketchbook of 1930: The toe and the toenail 22

— Woman with her hands akimbo 22

— The curtain 23

— The nail and the moon 24

— Woman and pitcher 24

— Woman and pitcher 24

— Caudal appendage 25

— Oval bisecting stilts 26

— Superimposed shapes 26

Woman, 1950. Bronze sculpture 26

Sketchbook of 1930: Twenty-seven drawings reproduced in their original size 28-54

Portrait of Mrs. Mills in 1750 (after George Engleheart), 1929. Oil on canvas. (45½ × 35") Collection, The Museum of Modern Art, New York. Gift of James Thrall Soby (Museum Photo) 55

La Fornarina (after Raphael), 1929. Oil on canvas. (57 × 45") Galerie Maeght, Paris 55

The Circus Horse (or Lasso), 1927. Oil on canvas. (51¼ × 37½") The Fogg Art Museum, Harvard University, Cambridge, Massachusetts. Gift of Joseph Pulitzer, Jr. 55

The Statue, 1925. Oil on canvas. (31½ × 25½") Marcel Mabille Collection, Brussels 55

Hand Catching a Bird, 1926. Oil on canvas. (36¼ × 28¾") Private Collection, Fontainebleau. (Photo Jacqueline Hyde, Paris) 56

Queen Louise of Prussia, 1929. Oil on canvas. (32 × 39⅜") Pierre Matisse Collection, New York . 58

Three preparatory drawings for Queen Louise of Prussia 58

Painting (or Mediterranean Landscape), 1930. Oil on canvas. (92½ × 61") Private Collection, U.S.A. . . 59

Painting, 1930. Oil on canvas. (59 × 100½") Museu de Arte Moderna, Rio de Janeiro, Brazil . . . *lower left* 59

Painting, 1930. Oil on canvas. (59 × 88½") Menil Family Collection, Houston, Texas . . . *lower center* 59

Painting, 1930. Oil on canvas. (59 × 90½") Present whereabouts unknown *lower right* 59

Small notebook : Mediterranean landscape 60

— "Pasted leaves" 60

— "The Magic of Color" 61

— Mountain 61

Alicia, 1965-1967. Ceramic mural executed in collaboration with Joseph Llorens Artigas. (97 × 228½") The Solomon R. Guggenheim Museum, New York. Gift of Harry F. Guggenheim. (Museum Photo) . 62

Sketch for Alicia. Drawing, 20 February 1960 62

Sketch for The Hunter (Catalan Landscape) 63

The Farm, 1921-1922. Oil on canvas. (52 × 58") Mrs Ernest Hemingway Collection 64

The Tilled Field, 1923-1924. Oil on canvas. (26 × 37") The Solomon R. Guggenheim Museum, New York. (Photo Robert E. Mates) 65

The Hunter (Catalan Landscape), 1923-1924. Oil on canvas. (25½ × 39½") Collection, The Museum of Modern Art, New York. Purchase (Museum Photo) 65

The Smoker, 1925. Oil on canvas. (25¼ × 19¼") Sir Roland Penrose Collection, London 66

"Catalan peasant—Catalan landscape." Drawing . . . 66

"Pastorale." Page from a notebook 67

"Tilled field (the house)." Page from a notebook . . . 67

Carob tree. Page from a notebook 68

Catalan Peasant's Head, 1924-1925. Oil on canvas. (18½ × 17¾") Private Collection, Paris 68

Preparatory drawing for Catalan Peasant's Head . . . 68

Preparatory drawing for The Trap 69

"Sourire de ma blonde," 1924. Oil on canvas. (34⅝ × 45¼") Simone Collinet Collection, Paris . 70

Sketch for "Sourire de ma blonde" 70

The Birth of the World, 1925. Oil on canvas. (96½ × 76¾") Collection, the Museum of Modern Art, New York. Acquired through an anonymous fund, the Mr. and Mrs. Joseph Slifka and Armand G. Erpf Funds, and by gift from the artist, 1972. (Museum Photo) 71

Sketch for The Birth of the World 71

Dog Barking at the Moon, 1926. Oil on canvas. (28¾ × 36¼") Philadelphia Museum of Art. A. E. Gallatin Collection 72

"Puppy yapping at the moon." Sketch for Dog Barking at the Moon 72

Sketch for The Siesta 73

Sketch for The Siesta 74

The Siesta, 1925. Oil on canvas. (37 × 57½") Mellon Collection, Washington 74

Landscape (or The Grasshopper), 1926. Oil on canvas. (44⅞ × 57½") Mr. Basil P. Goulandris Collection, Lausanne 75

Sketch for The Grasshopper 75

Three sheets with sketches of insects 76-77

Person Throwing a Stone at a Bird, 1926. Oil on canvas. (29 × 36¼") Collection, The Museum of Modern Art, New York. Purchase. (Museum Photo) . . . 78

Two sketches for Person Throwing a Stone at a Bird . 78

Maternity, 1924. Oil on canvas. (35¾ × 28¾") Private Collection, London 79

Two sketches for Maternity 79

Squared preparatory drawing for Spanish Dancer . . 80

Two sketches for Spanish Dancer 80

Spanish Dancer, 1924. Oil, charcoal and tempera on canvas. (96½ × 60⅝") Madame Jane Gaffé Collection, Cagnes, French Riviera 81

Portrait of Mrs. K., 1924. Oil, charcoal and tempera on canvas. (45¼ × 35") Madame Jane Gaffé Collection, Cagnes, French Riviera 82

Two sketches for Dancer 83

The Somersault, 1924. The Yale University Art Gallery, New Haven, Connecticut. Gift of the Société Anonyme 83

Preparatory drawing for The Harlequin's Carnival . . 84

The Harlequin's Carnival, 1924-1925. Oil on canvas. (26 × 36⅝") The Albright-Knox Art Gallery, Buffalo, New York 84-85

"Frog's head, Harlequin, Rooster's head." Sketch for The Harlequin's Carnival 86

"In the background the Seine and the Eiffel Tower." Sketch for an illustration for a projected but unwritten book by Robert Desnos 86

Sketch for The Wind 86

The Wind, 1924. (23⅝ × 18⅛") Aragon Collection, Paris 87

Sketches for two pictures never painted: "Viticulture" and "Toys" 88

Sketch for Woman on the Beach 88

The Farmers' Meal, 1935. Oil on cardboard. (29½ × 41¾") Mr. Thomas C. Adler Collection, Cincinnati, Ohio 89

Page of sketches for The Farmers' Meal 89

Two drawings for Lovers, 1925 90

Embracing lovers. Drawing, 16 August 1942 91

Drawing on the theme of adultery 91

Study sheet on the theme of lovers. Varengeville, 6 March 1940 92

Study sheet on the theme of lovers. Varengeville, 7 March 1940 93

Study sheet for Lovers. Palma, 31 October 1940 . . . 94

Study sheet for Figures in the Night. Palma, 12 December 1940 95

Cover design for "Minotaure," No. 7, Paris, June 1935 96

Preparatory drawing for In Memory of a Poem. Palma, 30 October 1940 98

Sketch for The Matador's Toast 98

The Beautiful Bird Revealing the Unknown to a Pair of Lovers, 1941. (One of the series of twenty-three Constellations, 1940-1941) Gouache and oil wash. (18 × 15") Collection, The Museum of Modern Art, New York. Acquired through the Lillie P. Bliss Bequest, 1945 99

Sketch for Drawing-Room Gossip 100

Painting, 1936. Egg tempera on masonite. (30¾ × 42½") Present whereabouts unknown 100

Painting, 1936. Egg tempera on masonite. (30¾ × 42½") Galerie Maeght, Paris 101

"Man, woman and rainbow on a blue ground..." Sketch for a painting 101

Bullfight, 1925. Oil on canvas. (23⅝ × 36¼) Ezra Nahmad Collection, Milan 106

Bullfight, 8 October 1945. Oil on canvas. (44⅞ × 57½") Musée National d'Art Moderne, Paris. (Photo Musées Nationaux) 107

Preparatory drawing for In Memory of a Poem. Palma, 20 September 1940 108

Four illustrations for Lise Hirtz, "Il était une petite pie," Editions Jeanne Bucher, Paris, 1928. From the copy in the Claude Givaudan Collection, Geneva. (Photo Bouverat, Geneva) 108

Manuscript page and sketches in the notebook "Souvenir d'un poème" (In Memory of a Poem), 1940-1941 109

Preparatory drawing for In Memory of a Poem. Palma, 30 October 1940 109

Drawing with figure and star in the notebook "Souvenir d'un poème" (In Memory of a Poem). Montroig, 8 September 1941 111

Sketch for Figure, Moon and Star in the notebook "Souvenir d'un poème" (In Memory of a Poem). Montroig, 9 September 1941 112

Sketch for Figure, Moon and Star in the notebook "Souvenir d'un poème" (In Memory of a Poem), 1940-1941. Inscribed Joan Miró 112

Woman in the Night, 1942. (24¹/₂ × 18¹/₈") Present whereabouts unknown 113

Woman Listening to Music, 11 May 1945. (51¹/₄ × 66¹/₈") Hans Neumann Collection, Caracas, Venezuela . 114

Dancer Listening to the Organ in a Gothic Cathedral, 26 May 1945. Oil on canvas. (76³/₄ × 51¹/₈") The Jeffrey H. Loria Collection, New York 115

Sketch for Women on the Beach. Large Palma notebook, 1940-1941 117

Figures in the Night Guided by the Phosphorescent Tracks of Snails, 12 February 1940. (One of the twenty-three Constellations, 1940-1941) Gouache and oils thinned with turpentine on paper. (15 × 18") Mr. Louis Stern Collection, U.S.A. . . . 118

Toward the Rainbow, 11 March 1941. (One of the twenty-three Constellations, 1940-1941) Gouache and oils thinned with turpentine on paper. (18 × 15") Mrs. Patricia Matisse Collection, New York 118

Majorcan xiulets (painted terracotta whistles). G. P. Collection, Paris. (Photo Jacqueline Hyde, Paris) . . 118

Cave painting at La Graja Miranda del Rey (Jaén), Spain. (After Abbé Breuil) above 119

Cave painting at Las Batuecas (León), Spain. (After Abbé Breuil) below 119

"The song of the blue-throated warbler..." Page from the 1940 Palma notebook. Palma, 23 December 1940 121

"The wings of a sea swallow..." Page from the 1940 Palma notebook 122

Squared preparatory drawing for Bullfight. Page from the notebook "A Woman," 1940-1941 127

Preparatory drawing for The Family. Page from the notebook "A Woman," 1940-1941 127

Preparatory drawing for Bullfight. Page from the notebook "A Woman," 1940-1941 130

"A woman." Sketch and manuscript page in the notebook "A Woman." Palma, 30 December 1940 . . 131

Seated Woman I, 4 December 1938. Oil on canvas. (63³/₄ × 51¹/₄") Peggy Guggenheim Collection, Venice 131

"A woman." Sketch and manuscript page in the notebook "A Woman." Palma, 30 December 1940 . . 132

Self-Portrait I, 1937-1938. Pencil, crayon and oil on canvas. (57¹/₂ × 38¹/₄") Private Collection, New Canaan, Connecticut 133

Self-Portrait, 1960, painted over a facsimile of Self-Portrait I. (57¹/₂ × 38¹/₄") Galerie Maeght, Paris . 133

Lithograph illustration for "L'Aube des voyageurs," poem by Tristan Tzara, Editions de La Montagne, Paris, 1930 137

Manuscript page with sketches. From the Orange Notebook, 1940-1941 139

Figures and Birds in the Night, 1939. Oil on canvas. (25¹/₂ × 19³/₄") Pierre Matisse Collection, New York 140

Illustrations for "De l'assassinat de la peinture à la Céramique," 1944 143-153

The photographs of drawings in Miró's notebooks were made by F. Catalá Roca, Barcelona.

157

SKIRA

PUBLISHED JUNE 1977
PRINTED BY
IMPRIMERIE STUDER S.A., GENEVA

PRINTED IN SWITZERLAND